Robin Hood

People's Outlaw and Forest Hero
A Graphic Guide

Paul Buhle

*Illustrations by Chris Hutchinson,
Gary Dumm and Sharon Rudahl*

Robin Hood: People's Outlaw and Forest Hero; A Graphic Guide
Paul Buhle with illustrations by Chris Hutchinson, Gary Dumm and Sharon Rudahl

ISBN: 978–1–60486–318–5
Library of Congress Control Number: 2010916481

Cover by John Yates / www.stealworks.com
Back cover image: "CLR James – The Midnight Robber" banner by Mike Alewitz
5' x 7' / 2010 www.alewitz.com
Interior design by briandesign

10 9 8 7 6 5 4 3 2 1

PM Press
PO Box 23912
Oakland, CA 94623
www.pmpress.org

Printed in the USA on recycled paper, by the Employee Owners of Thomson-Shore
in Dexter, Michigan.
www.thomsonshore.com

Contents

Acknowledgments

Much thanks to the editors and production folks at PM—especially Ramsey Kanaan, Romy Ruukel, Gregory Nipper, and Brian Layng—and to the critics of the text who generously gave us criticisms on matters large and small: Kent Worcester, Dave Wagner, Bill Jones, Albert Ruben (a script editor of television's *Adventures of Robin Hood*), and Nick Whitam. David Berger's exceptional knowledge about British life, literature, and culture at large has been a great help. The Scurrah Wainwright Trust and Charity supplied funds for the illustration of this book, and their assistance is gratefully acknowledged. In lieu of a formal dedication, I would like to remember two great historians—my friend E.P. Thompson and my mentor, C.L.R. James—and one great screenwriter, my oral history subject Ring Lardner, Jr., who more brilliantly than anyone else in the twentieth century made Robin an eternal revolutionary.

Why Robin Hood? Why Now?

"When the forest was cut down, where did the mystery go? Some say there were fairies in the forest—angry, bad-tempered creatures (the unwashed children of Eve), ill-met by moonlight, who loitered with intent on banks of wild thyme listening furiously to the encroaching axes. Where did they go when the forest no longer existed?"

—Kate Atkinson, *Human Croquet* (1997)

"The traditions which nourished Shakespeare or Dante or Homer—the cross-cultural traditions which nourished those writers and which bore upon the great pre-Columbian sculptors—those traditions are alive, and buried within ourselves, within the world's unconscious. . . . There is a tradition. . . . which nourishes us even though it appears to have vanished."

—Wilson Harris, "Cross Cultural Community and the Womb of Space," *The Selected Essays of Wilson Harris: The Unfinished Genesis of the Imagination* (1999)

In the late 1950s, a handful of peaceniks protested mandatory ROTC on a major U.S. university campus by carrying signs and wearing green buttons. Back when *The Adventures of Robin Hood* was a giant hit on television, most everybody knew that green was Robin Hood's color and that Robin could not side with the king's soldiers or future soldiers of any Empire. Five decades later, the lead protagonist of a cult favorite American cable show, *Leverage*, announces at the beginning of each episode: "The rich and the powerful take what they want; we steal it back for you."

It's a fitting motto for heroes of the twenty-first century. Admittedly, resistance to injustice has not as yet returned to the level of those apprentices and craftsmen in Edinburgh, Scotland, who in 1561 chose to come together "efter the auld wikid maner of Robene Hude": they elected a leader as "Lord of Inobedience" and stormed past the magistrates, through the city gates, up to Castle Hill where they displayed their unwillingness to accept current work-and-wage conditions. But as a global society, we are clearly still thinking about the *need* for Robin Hood.

After all, we live in something rapidly approaching a Robin Hood era. The rich and powerful now command almost every corner of the planet

and, in order to maintain their control, threaten to despoil every natural resource to the point of exhaustion. Meanwhile, billions of people are impoverished below levels of decency maintained during centuries of subsistence living. In this historical moment, the organized forces of egalitarian resistance and even their ideologies seem to be reduced to near nonexistence, or turned against themselves in the name of supreme individualism. Robin's Greenwood, the global forest, is disappearing chunks at a time. Yet, resistance to authority, of one kind or another, continues and, given worsening conditions, is likely to increase. Robin Hood lives on as a figure of tomorrow, rather than just yesterday, in the streets of Cairo, Egypt, and Madison, Wisconsin, USA, among the many other places where people dream of a better life and struggle for it openly, cheerful to be rebellious.

No other medieval European saga has had the staying power of Robin Hood; no other is wrapped up simultaneously in class conflict (or something very much like class conflict), the rights of citizenship in their early definitions, defense of the ecological systems against devastation, and the imagined utopia of freedom disappearing into a mythical past with centuries-long village Mayday festivals with music, dance, and heavy undertones of fertility rites.

No wonder, then, that theater and poetry seized the subject early on, and that modern communications, from nineteenth-century penny newspapers and "yellow back" cheap novels to modern-day comic strips, comic books, pulp magazines, and assorted media have all had their Robin Hood characters. No wonder that the early Robin films set records for lavish production and box-office records for audience response. No wonder that television productions of Robin have pressed issues of civil liberties and that many of the later films, if distinctly mediocre, nevertheless seem to refresh the subject, offering a source of summer holiday distractions that never quite disguise darker themes within. The most successful of television lyrics for this theme, ending, "Feared by the bad/loved by the good/Robin Hood," still offer reminders for aging sentimentalists of the Civil Rights and New Left days. Devised for the hit series of the 1950s, actually written by Marxist-minded men and women on the run from the FBI, *that* Robin Hood perfectly expressed the subtler forms of struggle against Empire. And the series was really funny, too.

Robin Hood's status may be especially important in our time of extended imperial crises. In an understated 1976 film, *Robin and Marian*, directed by the talented avant-gardist Richard Lester, the protagonist is a weary veteran of the Crusades (needless and bloody invasion/occupations). Sean Connery's Robin, Audrey Hepburn's Marian (who in this version is a prioress aiding the poor while battling against authorities) and Robert Shaw's repressive but deeply fatalistic Sheriff of Nottingham light up the screen in a film shot beautifully in a Spanish forest that looks like some untouched Sherwood. It is the only film version in which Robin dies.

The blowback of the Crusades brings a dose of multiculturalism: not the threat from "outsider" Arabs so much feared after 9/11, but the persona of the Outsider who has, since at least the early 1990s, become necessary for the plot. Kevin Costner's Robin in *Robin Hood: Prince of Thieves* has for this reason a friendly "Saracen," played by Morgan Freeman. More interesting adaptations to follow have Middle Eastern herbalists, especially women, and even the occasional Rastaman whose presence reflects the Anglo-Caribbean uses of Robin Hood against Empire. Following the similarly pointless and bloody U.S. invasion of Iraq and Afghanistan, the crisis of Empire is seemingly an inescapable part of Robin's fate and his repertoire.

Most recently, however, Ridley Scott's 2010 mega-feature *Robin Hood*, easily among the least faithful adaptations of Robin's tale ever made, has placed Robin in battle, in a massively staged prequel, with hundreds of armed and warring soldiers previously unknown to the Robin narrative. This Robin also seeks to redeem or at least defend embattled villagers, but in practice, only manages to protect one empire against another. The appearance of the film and its massive accompanying publicity nevertheless sparked yet one more in a seemingly endless series of Robin revivals. Within the months before and after the film's release, a handful of new books appeared, along with the publication of new scholarly studies, new Robinesque features of local summer festivals, an occasional Robin Hood musical comedy, and a spate of other Robin-connected publicity. The contexts of the films, books (mainly novels for young readers), plays and theme-events are so varied, the purposes so divided between money-making, rebellious sentiment and good-weather exuberance, that any effort to divine a single meaning to them all would be foolish. We know that Robin Hoodness is alive and well, with all its complications.

In his famous scholarly analysis, British historian Eric Hobsbawm dubbed the "Robin Hood-type outlaw" a "primitive rebel," because the outlaw lived in a peasant society with no prospect or even idea of social transformation. The outlaw did, however, have the sympathy of the oppressed people, especially those whose lands had been recently stolen by lords, merchants, invading forces allied with local barons, or anyone with the armed power to do so. Robin Hood, then, the rebellious persona considered generically, is a wider "type." He seems to have shown up in nearly every mountain range, jungle, or distant desert—any geographical condition allowing an elusive outlaw with a following to hide safely from the authorities for months or years at a time. Real-life Robin Hoods, like Mexican peasant leader Emiliano Zapata (and the less-remembered, regional Mexican revolutionary and transnational Wobbly, Primo Tapia) and Che Guevara, met typically sad fates: the armed state (or regional empire) crushed their following and almost always executed the leader. Mythical Robin Hoods, on the other hand, are never captured, because their cause must live on, even if it fades out for generations and must be reborn in popular sentiment rather than real life.

In *Robin Hood: People's Outlaw and Forest Hero*, we stick largely to Anglo-American traditions (with a late bow toward the Anglophone Caribbean), but not because they are more interesting, or more important than other outlaws across the world and across time. Rather, the traditions have been framed in certain ways, ripe with rebellious implications, such that a social historian (like the author) with a long-standing interest in radicalism can get a handle on them properly.

The main argument here, put most simply, is that the conjunction of an eight-century-long saga of heroic rebellion with myth, ritual, popular, and commercial culture of all types and, in its formative days, with insurrection and religious dissent, cannot be a coincidence. Robin Hood stands for something that holds out against the powers-that-be, especially when social stresses bend and break existing bonds of consent from the weaker to the more powerful. The saga of Robin Hood is not a metaphor easily adaptable to Marxist (or anarchist) formulation. Rather, it opens up badly needed areas of discussion after the collapse of Russian-style Communism and the near-collapse of capitalism's self-confidence, amid crises in the global economy and worse crises in the planet's ecosystems.

Between Robin's early popularity and the modern age rests the first great era of peasant rebellion and the Radical Reformation. Every major uprising against King (or local nobility) and Church, it is fair to say, promised something more than regional, national or ethnic autonomy: the goal was to roll back history, to return to some kinder, more cooperative age. This is especially important for those shrewd historians who suggest that "Socialism" as a historic mass movement has been inspired as much by a look backward in time as by a look forward. But for anyone who seeks to understand religion's ethical origins and symbolic meaning as deeper and more complex than any organized sect's legitimation of class rule, Robin will continue to be of great interest.

Robin, a good box office bet for at least six centuries, will doubtless go on that way for centuries more, and for that reason alone would (and will) remain a useful political symbol. Most recently in the UK, the proposal of a "Robin Hood Tax" on financial transactions, backed by a wide range of unionists and charity organizations, was launched with a comic promotional short directed by Richard Curtis (of *Four Weddings and a Funeral*). The swindling class, together with their paid politicians of all major parties, naturally opposes such a tax. King John is still on the throne, so to speak, and there is no Good King Richard in the distance.

Robin's legacy is also a gold mine for generations of hobbyists: hikers seeking his grave, or where some arrow of his purportedly fell, and places where he might have lived and struggled. Ramped up by amateur scholars poking through local documents for poetry and theatrical materials about Robin in sequestered manuscripts, the search continues to the present day

and doubtless far beyond. There are always fresh claims to be made on various grounds and likewise disputed. The Robin Hood Project at the University of Rochester in New York offers a scholarly version of fan enthusiasm with a fine website, full of materials that were once the province of hobbyists alone, undoubtedly encouraging still more hobbyists now and in the future. Clearly, Robin will never cease to fascinate large numbers.

Other types of scholars, most of them self-made Americana experts, have probed the pulp literature of the nineteenth century—the original television, so to speak—and found that virtually every popular romantic outlaw, Texas Jack to Jesse James and Billy the Kid and dozens more, is described somewhere as a Robin Hood *of* something or, more usually, somewhere. During the same period, Mark Twain's Tom Sawyer is said to be ignorant of Scripture excepting his own—that is, Robin Hood stories. (In the final chapter, we return to Tom Sawyer and Robin.)

Robin Hood's other symbolic connection with global lore, especially Old West lore, is the arrow. Robin appeared or is said to have appeared around the same century as Wilhelm Tell, the mythic hero of Switzerland, who used a crossbow rather than a long bow. Each of the two figures have something approaching a supernatural skill with the bow, making them archetypes for literary sagas of the eighteenth and nineteenth centuries and all manner of popular cultural adaptations, including innumerable humorous riffs, since then. The cowboy, exemplified in Owen Wister's genre-setting novel *The Virginian*, possesses the same supernatural knack with the six-shooter, as have the "soft" cowboy-outlaw derivative types like the Lone Ranger, who often manage rather miraculously to nick a wrist with a bullet rather than shoot the varlet dead.

The arrow's metaphor has applied not only to white man. On the contrary, the arrow was the weapon of guerilla warfare practiced by the American Indians who struggled mightily if unsuccessfully to keep their own transhistoric claims upon the landscape. Moreover, the native guerilla warfare that was being overwhelmed even before 1776 nevertheless taught the white colonists how to fight the British, hiding and strategizing rather than marching in units ready to be cut down by rifle ball or swordplay.

The significance of the arrow metaphor did not end with the final "bad" (or even "good") Indian killed by rifle in the endless series of vaudeville, theatrical, and filmic dramas. Case in point: *The Flame and the Arrow* (1950), the last film written by Waldo Salt—later of *Midnight Cowboy* and *Serpico*—before he was blacklisted, has a left-inclined guerilla fighter holding off a tyrant in the mountains around Lombardy in northern Italy, sometime centuries earlier. This charmingly virile outlaw, played by none other than Burt Lancaster, lives in the section of the forest where even the king's hawks do not rule the sky. Outlaws enter town on the night of the carnival, of course, overwhelming the armored king's men with their acrobatics. Virginia Mayo,

playing the princess, and Aline MacMahon, playing the leader of the village women, exercise decisive roles in the overthrow of the evildoers. The king has guns, the peasants have arrows. For that moment, brilliantly aimed arrows are enough. For Salt, as for many progressives in Hollywood and beyond, the anti-Fascist Partisans were still fighting, this time against the global, neo-colonial Empire based in Washington, from locations in Asia, Africa, and Latin America.

We take inspiration in this small book from some other scholarly pred-ecessors and one in particular. Joseph Ritson, a contemporary of William Blake and a radical freethinker of his time, set the Robin Hood/outlaw image in place with his 1795 collection of Robin Hood ballads and his own extended introduction to the material. Like many outlaws, Ritson's Robin was brave, strong, and canny. His Sherwood Forest giant was also, to offer a twentieth-century American counterpart, the equivalent of Eugene V. Debs or Martin Luther King, Jr.: a giant of kindness, with a vision of how the world might be a better place through removal of impediments and restoration of some more "natural" order.

Not all scholars hold this view, of course. In a rather dismissive new introduction to a classic work of the British Marxist Rodney Hilton, on the uprising of 1381 that made Robin Hood folklore possible or necessary, British academic Christopher Dyer reassures us that "Robin Hood ballads are now seen as having a universal appeal—everyone enjoyed escapist stories about a mischievous anti-establishment bandit." With a sweep of the hand, Hilton's view on Robin and class conflict is replaced with that of Robin as fluffy modern entertainment with no purpose beyond diversion. Robbing from the rich and giving to the poor? Just mischief, insists Professor Dyer. Never more than mischief.

Such is not the view of the author and the artists of this book. Quite the contrary.

Why do we choose Robin, when there is an abundance of other rebel archetypes available? I argue that Robin is not only the basis for one kind of outlaw-hero of the so-called Wild West, in the genre that has dominated so much of popular culture across the twentieth century and into the twenty-first, but for a kind of media hero at large. Likewise, in the small but politi-cally significant genre of dissident culture, Robin Hood has offered a model figure for the Resistance in films or television shows about the Second World War, and then on to a genre of television (and a few films) where heroic figures (or groups) steal back from the rich their ill-gotten gains. No end in sight, and that's a good thing. If Robin stands higher than any other figure in English lore, even King Arthur, it is because he is mythically still in the Greenwood, waiting.

REFERENCES

Kate Atkinson, *Human Croquet* (London and New York: Doubleday, 1997).

Maurice Cornforth, ed., *Rebels and Their Causes: Essays in Honour of A.L. Morton* (London: Lawrence and Wishart, 1978), including Eric Hobsbawm, "The Historians' Group of the Communist Party," and Christopher Hill, "From Lollards to Levelers."

Rodney Hilton, *Bond Men Made Free: Medieval Peasant Movements and the English Rising of 1381* (London: Routledge, 2003), including a new introduction by Christopher Dyer.

Eric Hobsbawm, *Social Bandits and Primitive Rebels: Studies in Archaic Forms of Social Movement in the 19th and 20th Centuries* (Glencoe, IL: The Free Press, 1959).

Peter Linebaugh, *The Magna Carta Manifesto: Liberties and Commons for All* (Berkeley: University of California, 2008).

Peter Linebaugh, "The Secret History of the Magna Carta," *Boston Review* 28 no. 3–4 (Summer, 2003).

Peter Linebaugh, "Wat Tyler Day," *Counterpunch*, June 13, 2008, http://www.counterpunch.org/2008/06/13/wat-tyler-day/.

CHAPTER 1
Robin's Historical Contexts

152A.1 WHEN as the sheriff of Nottingham
Was come, with mickle grief,
He talkd no good of Robin Hood,
That strong and sturdy thief.
Fal lal dal de

152A.2 So unto London-road he past,
His losses to unfold
To King Richard, who did regard
The tale that he had told.

152A.3 'Why,' quoth the king, 'what shall I do?
Art thou not sheriff for me?
The law is in force, go take thy course
Of them that injure thee.'

—From the *Childe Ballads*

Robin Hood's continuing celebrity makes sense only as part of a very real social history and also a very real history of literature within a wider popular culture. The crises and conflicts of the early Middle Ages, recuperated by (among others) Victorian Britain's favorite socialist poet, William Morris, are still yielding fresh insights to researchers. These hints and details are, of course, most important to scholars and activists who seek to create anew the world that Robin mythically struggled to defend. By looking at the medievalism and its meanings, we can get a sense of how much the past, even a distant past when religion permeated daily life, continues to mean, and not only to the English.

According to some of today's scholars, Robin Hood has survived and prospered precisely because of his ambiguous character. William Morris, master designer and collaborator with the Pre-Raphaelites, father of British socialism and defender of the historic countryside, supplied a better explanation via a historical parable, in the form of a novella serialized in the weekly *Commonweal*, 1886–87. William Morris's time-traveler, leaping from the nineteenth to the fourteenth century in "The Dream of John Ball," thus comes

across a friendly if hard-pressed group of yeomen. He has, he swiftly learns, entered the past during an era of great troubles.

John Ball and Dreams of Liberation

All leapt up and hurried to take their bows from wall and corner; and some had bucklers withal, circles of leather, boiled and then moulded into shape and hardened: these were some two hand-breadths across, with iron or brass bosses in the centre. Will Green went to the corner where the bills leaned against the wall and handed them round to the first-comers as far as they would go, and out we all went gravely and quietly into the village street and the fair sunlight of the calm afternoon, now beginning to turn towards evening. None had said anything since we first heard the new-come singing, save that as we went out of the door the ballad-singer clapped me on the shoulder and said: "Was it not sooth that I said, brother, that Robin Hood should bring us John Ball?"

Our time-traveler knows, of course, that John Ball is going to lead the uprising, and will be martyred for his effort, but also that his legacy will survive and take on new meanings with the passing of ages. He wants to explain to the assembled working men, ready to take up their cudgels, that they have a great mission ahead.

So such a tale I told them, long familiar to me; but as I told it the words seemed to quicken and grow, so that I knew not the sound of my own voice, and they ran almost into rhyme and measure as I told it; and when I had done there was silence awhile, till one man spake, but not loudly:

"Yea, in that land was the summer short and the winter long; but men lived both summer and winter; and if the trees grew ill and the corn throve not, yet did the plant called man thrive and do well. God send us such men even here."

"Nay," said another, "such men have been and will be, and belike are not far from this same door even now."

"Yea," said a third, "hearken a stave of Robin Hood; maybe that shall hasten the coming of one I wot of." And he fell to singing in a clear voice, for he was a young man, and to a sweet wild melody, one of those ballads which in an incomplete and degraded form you have read perhaps. My heart rose high as I heard him, for it was concerning the struggle against tyranny for the freedom of life, how that the wildwood and the heath, despite of wind and weather, were better for a free man than the court and the cheaping-town; of the taking from the rich to give to the poor; of the life of a man doing his own will and not the will of another man commanding him for the commandment's sake. The men all listened eagerly, and at whiles took up as a refrain

a couplet at the end of a stanza with their strong and rough, but not unmusical voices. As they sang, a picture of the wild-woods passed by me, as they were indeed, no park-like dainty glades and lawns, but rough and tangled thicket and bare waste and heath, solemn under the morning sun, and dreary with the rising of the evening wind and the drift of the night-long rain.

When he had done, another began in something of the same strain, but singing more of a song than a story ballad; and thus much I remember of it:

The Sheriff is made a mighty lord,
Of goodly gold he hath enow,
And many a sergeant girt with sword;
But forth will we and bend the bow.
We shall bend the bow on the lily lea
Betwixt the thorn and the oaken tree.

With stone and lime is the burg wall built,
And pit and prison are stark and strong,
And many a true man there is spilt,
And many a right man doomed by wrong.

So forth shall we and bend the bow
And the king's writ never the road shall know.

Now yeomen walk ye warily,
And heed ye the houses where ye go,
For as fair and as fine as they may be,
Lest behind your heels the door clap to.
Fare forth with the bow to the lily lea
Betwixt the thorn and the oaken tree.

William Morris devoted great energy to the accuracy of details in setting and language. He wanted his mostly socialist readers to know just how the working people of long ago had lived, talked and (as far as possible to understand centuries later) thought. Akin to his designs of wallpaper recuperating "Celtic" themes, Morris's literary effort was to recreate a history that had been virtually lost and turned into a succession of kings and their sycophants.

John Ball was no mythic figure, but a real leader of a major social rebellion, assassinated as the rebellion was crushed in 1381. Little is known about Ball otherwise: like many an agitator, he was a lay preacher with working men and women as his street audience.

Ball was once thought to be the author of the totemic English poem of the time, *Piers Plowman*. The authorship was otherwise, but the kinship is striking. *Piers Plowman*'s complaint and demands, naturally placed during

that time in theological terms, nevertheless spoke to very real contemporary developments. These included a failed (but hugely expensive) Crusade; the creation of the historic 1215 agreement between king and aristocracy known as the Magna Carta; the rise of religious dissent and in particular those spiritual rebels, the Lollards; not to mention famine and plague, among other cataclysmic events of the time.

Behind this multiple crisis, before the resulting disruption and attempted revolution of 1381, lay centuries of European village life, more specifically the creation of a sustainable ecosystem in which the village had collectively survived invasions, diseases, and all manner of earlier threats. Peter Linebaugh quotes Marc Bloch's description of "grey, gnarled, low-browed, knock-kneed, bowed, bent, huge, strange, long-armed, deformed, hunchbacked, misshapen oakmen." The ancient oaks, Linebaugh says, were not the growth of "wildwood," dating back to the conditions formed by the Ice Age, but the consequence of a planned and cultivated, wooded *pasture*. This was a reality, but also a metaphor.

The wooded pasture was nurtured by the villagers within a common—that is, an area commonly held, with practices properly known as woodsmanship, so that the same stretches of land remained in use for their value as wood and for the grazing of their domestic animals. Ash and elm trees, capable of growing up from stumps, could be cut and used for rakes and scythes, not to mention firewood, while trees like apple and cherry, arising out of root systems as "suckers," grew rapidly out of reach of the livestock and would provide other resources.

Wooded commons were often owned by the local lord or merchant, but used by all. If the owner commanded the soil and exacted a percentage of crops, grazing rights nevertheless usually remained with commoners, and the trees belonged to neither. Thus, as the cattle grazed, towns were physically organized through the extensive use of wood in cottages, churches, and for the making of bowls, tables, stools, and wheels.

The Norman Conquest in 1066, a couple of centuries before Robin's supposed time, did much to throw these old rules of the forest into chaos. Changes brought new laws, new populations (including French and Jewish) and even new animals for game including certain kinds of deer not earlier seen in these lands. The forest, as Linebaugh says keenly, was now as much a legal as a physical presence.

Other elements of change likewise pressing upon villagers further complicated the picture. As Marxist scholar Rodney Hilton explained in his classic, *Bond Men Made Free: Medieval Peasant Movements and the English Rising of 1381*, serfdom expanded as the centers of power grew stronger and more successfully exploited the advancing sources of wealth, even as large numbers of "free tenants" remained protected to some degree against the seizure of all surplus through government and lordly dues and payments of

one kind and another. In many cases, farmers closer to markets were growing more prosperous, but they were also the very farmers with dues-collectors ever closer at hand. For centuries ahead, the collective resistance across Europe, but perhaps especially for the English, coincided with the sense of better days somewhere in the past, and this real and mythic memory continued to give ballast to class resentments and radical hopes alike.

In all this, the forest was a unique status symbol and a domain of kingship, both symbolic and actual. Royalty needed wood for all the familiar reasons of building and sustaining a palace life, as well as supporting the lives of merchants and nobility in league with the King. For holidays, they demanded sumptuous banquet food, including all manner of forest animal life, as well as fish that swam in the forest's rivers, and deer that were forbidden to be trapped, killed, and eaten by anyone else. Pickpockets, abundant at public events (including hangings), were more likely to be shown mercy than deer poachers, even with the animals in evident abundance.

We will see below that a real or mythic Robin Hood might play one large important role here by supplying villagers with desperately needed protein. Protein on the hoof, obvious in the presence of deer yet forbidden on penalty of death, caused real-life situations of a father watching his wife and children suffering. He could hardly resist the impulse to take bow in hand.

If not deer, then cash. Robbery and even murder (to eliminate witnesses) along forest lanes became common as merchant goods and funds, not to mention tax collectors, were seen as the suitable for plunder by the bold or reckless.

Cash was also necessary in part to meet the authorities' demands upon the villages and forests to make possible the latest forms of military escalation and associated expenses for the King's army. Royalty itself sold off forest privileges in order to pay the cost of mounted knights with or without armor. Predator missiles of the day, the armored men were intended to bring terror to the enemy (the enemy, that is, in distant parts of England to France and beyond, often enough consisting of stubborn but barely armed villagers rather than some other army) and at least equality of battle from kings and their knights on the other side of the Channel. Not surprisingly, then, one main demand in the Magna Carta was to take back the forests, or at least limit their expropriation by the powerful.

The Magna Carta was hardly written by common people, and it hardly ended oppression and exploitation. Like the later arrival of Protestantism, it often contributed to new conditions for heightened exploitation. But struggles against royalty and established Church offered symbols of popular resistance and occasional victory, symbols also used in the Robin Hood narratives. These helped make it *seem* possible to fight back, in small and mainly local ways; they made it seem possible, sometimes, to win back ancient rights that were in the process of being lost.

Thus it happened that the main ingredients of the Robin story became established in ballads, sung and written roughly between 1400 and 1500, with a handful of basic narratives starring the now familiar characters. From the beginning, their defense of villagers along with deer hunting, archery contests, cunning disguises, daring rescues, and crypto-romances were full of social and ecological implications, and always rich in symbolism.

Robin Hood, E.P. Thompson, and William Morris

Why was Robin Hood fascinating to William Morris, arguably the finest utopian writer of the nineteenth century? Why was Morris, in turn, so very important to the greatest of British historians, E.P. Thompson (charismatic leader of the European peace movement during the 1980s and orator of the mass marches in Britain against the preparations for nuclear war since the 1950s), that he chose the great socialist as the subject for an inspiring, massive study?

William Morris: Romantic to Revolutionary, Thompson's deeply emphatic biography, originally published in 1955, vindicated Morris as political radical, poet, and the father of the Arts and Crafts Movement, also as the extraordinary defender of "Older Days." Beloved among socialists across the earth, Morris believed in the "community" that had been achieved among ordinary people centuries earlier, despite unequal social classes and the brutal power of the Church.

This is a crucial point, often misunderstood by radicals and liberals, for generations optimistic about supermechanistic societies of the future. European socialist movements contemporary to Morris especially the German socialist movement enlisting such wide sectors of the working class by the 1880s and '90s that collective confidence in socialism's future seemed secure, nevertheless appeared to close observers to contain a strangely millennialist appeal. That is, Marxist ideas popularized for the masses were translated into holidays, costumes, marching, songs, and the deep-seated belief that capitalism was an *interruption* in history. The most popular explanatory socialist text of the day in Germany, the supposed home of socialism, was August Bebel's *Die Frau und der Sozialismus*, and the most popular chapter in that book a recollection of the "Golden Day" before the rise of class society. If a kind of socialistic, egalitarian society had indeed once existed, then it could arise again, but this time on a technically proficient level, with the good, healthy, abundant life for all.

The founding fathers of Marxism were plainly uneasy with some of the implications. If Friedrich Engels provided a splendid account of medieval peasant uprisings, there was still a sense in his writing that medievalism of any kind extended into the present-day mind was dangerously unscientific, potentially utopian. William Morris was also considered to be a bit of an anarchist, short decades after Marx had treated anarchist Mikhail Bakunin

as a blood enemy, and regarded heterodox socialists (like the Spiritualists and Free Lovers in the United States who had, in the years shortly after the Civil War, vastly popular appeal than the German-born Marxist faithful) as insufficiently proletarian as well as unscientific.

Much as those founding fathers enjoyed novels (and not especially radical novels or novelists; Balzac the royalist was Marx's own favorite), the role of creative art of any kind remained uncertain in the struggle for socialism. Should the socialist artist, novelist, playwright, or painter rouse the workers through realistic depiction of their suffering? Was maudlin treatment of their plight, seen through the misery of some beaten-down protagonist, mere sentimentalism?

Sophisticated theater had for generations taken a satirical stand toward the powerful classes. Middle-class theater of the later nineteenth century—typified by such powerful figures as Ibsen, Strindberg, and Shaw—tackled contemporary social issues, increasingly those of gender and class. Mass theater, a performance spectacle closer in resemblance to the circus (or carnival), was likely to be more physically expressive than "social," and when it was social, essentially melodramatic. The hero saved the girl from a dreaded fate at the hands of a greedy capitalist or exotic barbarians. Socialists and radical sympathizers meanwhile worked at all levels of art, low and high, for a living and as an expression of their artistic impulses. Like radical novelists, they tended to follow no set rules.

William Morris proved unique in all this because of his vision and his friends. Engels looked upon him skeptically, no doubt in part because Morris had developed a far-reaching system of cultural theories and expressions hardly dependent upon Marxism. Morris, great master of interior design, furniture to wallpaper, self-consciously recuperated the "nature" motif that had been part of English history since before the Roman invasions and occupations.

For these reasons, as well as a keenly developed sense for the environmental and human destruction that accompanied industrial production, Morris became the nation's foremost opponent of the destructive mentality aimed alike at ancient hedgerows (central to medieval agriculture) and old buildings. The Society for the Protection of Ancient Buildings, known popularly as "Anti-Scrape," saved countless structures and ecological spaces for future generations of residents, walkers, and tourists from around the world.

William Morris's popular historical romance tales and poems, a kind of medieval lore all to itself, seemed overwritten to future generations, but can be seen best in their milieu. Morris was, personally and artistically, intimately linked to his friends of the Pre-Raphaelite movement of artists and poets, one of the most important art movements of the century, and the inspiration for some of the most inspirational labor and radical art of any age. Walter Crane, whose drawings of nude figures against a rising

sun of hope for the future helped give generations of radicals the courage to take on overwhelming odds, epitomized how art could be for ordinary people and not only studio visitors, museum-goers, and the guests of private collectors.

News from Nowhere (1890), written a few years before Morris's death, appeared serially, like *A Dream of John Ball*, earliest in the first popular socialist newspaper in England, subsidized by Morris himself. After Edward Bellamy's *Looking Backward: 2000–1887* (1888), *News* was the most popular English-language, utopian socialist novel of a time when utopian romances appeared in great numbers. Rather than looking forward to a world with radio-like media-ready music and giant department stores as in *Looking Backward*, Morris's utopia really did look backward. There, his traveler found a low-tech paradise of people living peacefully in joyous nature including their own improved nature.

A few years earlier, when Morris acquired Howard Pyle's *Merry Adventures of Robin Hood of Great Renown in Nottinghamshire* (1883) shortly after the book's British publication, he was especially charmed by the illustrations of the American, a children's author-artist and a Pennsylvania Quaker. Pyle's drawings bore such a likeness to the work of the Pre-Raphaelites—and Pyle's use of the Quakerish "thee" and "thou" in his prose was similar to the archaic language in some of Morris's work—as to make Pyle an unmistakable and highly successful U.S. admirer of Morris, also in his own way the best continuator of the Robin Hood saga to date.

Pyle successfully captured the spirit of the rebellious Robin in the Greenwood, as experienced in English and Irish festivals as well as poetry and plays over centuries' time. By the middle of the twentieth century, Pyle's classic had been repeatedly rewritten, the illustrations replaced, regrettably, with bland modern ones, so that only the plot, the least original of Pyle's effort, actually remained. Morris had taken pleasure in Pyle's Robin without picking up his own pen to include Robin, save for the brief references in *A Dream of John Ball*.

E.P. Thompson, for his part, chose to leave Robin to his British Marxist colleagues. Thompson's effort instead went to that other great William of British radical history: William Blake, who shared a printer and political sympathy with Ritson. Thompson lacked the life-energy to complete a towering, massive biography of the monumental engraver and poet, but he tracked down the religious-radical sources of Blake's cosmology in the "Muggletonian" movement, a late eighteenth-century English counterpart to the continental followers of the mystic shoemaker, Jakob Boehme, known in England as "Behmen." Although scholars question the precision of this connection in specifics to Blake's church affiliation, the wider influence of "Behmen" on English artists of a mystical turn, including Blake himself, is certain.

Between the eras of Blake and Morris, Thompson was wont to say, something had been lost that might be regained, if at all, with deep thought as well as heroic effort, less by "scientific socialism" than by a radical recuperation of romanticism. Blake had hinted at something like this in mysterious passages and an occasional rage at the sufferings brought by "Satan's dark mills," poisoning children and eradicating Nature's bounty. Morris, as a popular naturalist and nature-oriented short story writer and poet, had made the message more vivid and comprehensible.

What Morris did in his nature-lore, his medieval romanticism, and the character of his utopianism seems to me at the heart of Robin Hood's meaning or meanings. Morris saw that socialism or any hope for a different future rested in no small measure upon a willingness to look back: not to claim that common life in society was better in, say, the tenth or fifteenth centuries, even at times when people had risen up in solidarity. Rather, Morris looked back so as to get a better glimpse of the different, more cooperative futures that might have lain ahead, futures that have been closed off, one by one, at least up to now. For those (and they included some of E.P. Thompson's intellectual and political opponents within the British New Left of the 1960s and '70s) who insisted that no proper radicalism, that is, no French- or German-style radicalism, had ever existed in Britain, Robin Hood would have been considered the quasi-hero sold as a commodity, early and late, in Britain and abroad. For Robin Hood to mean something, the larger something had to have existed within British historical and folk traditions.

Robin Hood could hardly be described as the *first* great anti-imperial rebel. Spartacus of antiquity, no myth but a real physical revolutionary, still owns this claim by arousing slaves against the Roman Empire in the greatest organized revolt of the lowly until the Black Jacobins' revolution in Haiti around the time of the French Revolution. In some respects, Robin Hood offers a bridge between these mighty events as the rebellion that does not overthrow, but nevertheless refuses to go away.

The tale of Robin Hood and its endless return in every medium is a variation on a near-universal story of rebellion in premodern societies that has a lasting impact as sustained myth or collective memory in a world where peasants, in their final redoubts, fight back as their resources are poisoned and stolen from them. The rebel in the outlands (mountains, desert, islands across a sea) takes on the rich on behalf of the poor and continues to do so as long as there is breath in him.

In *A Dream of John Ball* and other writings, then, Morris looked back in order to look forward, to the prospect of an uprising that created "Dual Power" uniting people of different classes against what the twentieth century would understand as Fascism, and the twenty-first century understand as the neoliberal/neoconservative catastrophe.

The Friar Tuck Question: Lollardy as Liberation Theology

Scholars of the Radical Reformation (which can be roughly described as a historical process of radicalized religion that climaxed a few centuries later but had its origins around Robin's time) remind us that there can be no clear demarcation between the theological and the political, even if the process of modernizing leads toward class uprisings. Discontent took shape within the available forms, and the literate minority would naturally have tapped for inspiration existing religious ideas, some of them very old and hidden within a more recent Christianity.

Since the collapse of the Roman Empire, the Church had remained intact as a center of learning; whatever their limitations, the various monastic orders valued not only literacy and fine arts but also agricultural and industrial techniques. They served not only the rich but the wider community as well. While committed formally to the abolition of preexisting religions, many priest-scholars and Christian laymen alike absorbed plenty of Celtic lore and assorted folk religions, most obviously in poetry and story-telling at large as well as in ways of explaining life's mysteries adapted to what common folk thought and felt. Any armed defense against invaders called still further upon existing traditions, and tended to put aside the suspicion of un-Christian heresies until some uncharted future.

The moral decline of the Church as a social institution was in large part self-created, as monastic orders increasingly became huge landowners and exploiters, a vital cog in the advancing feudal state. This impulse was accelerated, inevitably, by the cost of war and empire, especially but not only via the Crusades. The State and its nobility needed cash. In the lists of sins committed by peasants, the failure to tithe adequately and on time was at the top; the fate of the soul, saved or otherwise, was further down and obviously of less interest. Popular hatred of the Church thus grew, along with the suspicion that the clergy close at hand were increasingly involved in usury. The fights over power in Rome and the occasional creation of competing entities still further undercut the moral claims of the clergy.

Meanwhile, laymen of the upper classes were becoming more widely literate. By traveling more, many experienced the corruption of Rome in person, watching the shameless selling of pardons and peddling of fake relics. Pilgrimages, an early version of tourist destinations, also supplied an opportunity for sales of all manner of goods, not to mention lodgings and food. The Friars, making a half-hearted attempt at reform—they believed in poverty and simplicity, as well as democratic teaching, but they were hopelessly compromised by their faithfulness to Rome—inadvertently stirred up further popular feeling. Someone very much like Friar Tuck seems to predate Robin in lore (Maid Marian, eventually to become a sort of Mariolatry figure, follows both) as a rascal who ran with outlaws and turned against authority, ecclesiastical and domestic alike. He was a "people's priest," one in a long

future line extending into the twenty-first century. That he was fat and silly added to his disguised intent, as he pretended to do his ordered tasks for Rome and local Bishops.

In response to the real-life conditions of mid-thirteenth century, John Wycliffe, a respected Oxford don, theologian and biblical scholar, began to organize gatherings of radicalized Oxford students. His emphasis on the inward aspects of spirituality, the mystical source of grace revealed to all of God's People in the Bible itself, repudiated the existing Church basics. Even the Eucharist was placed under a great question mark: what right had the priest, who was acting for the Church, to administer Christ's Body, figuratively or literally, to believers?

According to Wycliffe's suggestions, believers themselves, not the Church, would be responsible for the judgments of conscience. They would do so by meditation and good deeds but above all through reading and understanding the source of all insight, the Good Book.

Their conclusions included far-sweeping reforms that Robin would surely have endorsed: the prejudice against sex and against women, the elaborate and expensive ceremonies, the unification of church and civil power in a single hierarchy, the pointless slaughter in war and the very manufacture of gold and armor as a pointless waste of resources and skill were all condemned.

By 1380, Wycliffe's texts had begun to appear in English, putting the Latin version on the back burner for ordinary literate people and allowing them to read passages aloud in English to sympathetic illiterates. His partial translation of the Vulgate Bible appeared the next year—the year of the great uprising—with more copies becoming available year by year. Friends and colleagues completed the translation for publication in 1388 and a more readable version in 1390. The latter edition became known as the Lollard Bible and was banned in the early part of the following century.

Groups of lay preachers moved around the English countryside from the early 1380s onward, offering a new and radical doctrine based roughly on Wycliffe's preachings. Above all, the reading of the Holy Scripture in the vernacular was taken as the route to the real Word of God. Personal faith even included the right of women to become preachers.

So vehement was their denunciation of the Church and its wealth that their antichurch doctrines could easily be called anticlerical. Known sometimes as "Wycliffites," they became more popularly known as "Lollards." The very origin of the word is uncertain. A Dutch word, "lollaerd," signified a mumbler, someone who mutters, and was related to "lull," as in a sing or chant; the Middle English "loller" was considered a lout, a lazy vagabond, an idler, a fraudulent beggar. Either interpretation fits the furtive nature of a movement that faced bitter criticism and violent suppression, with biblical passages spoken as quietly as necessary.

Close to campus, Lollardy excited the broader Oxford community as well, and Lollard sermons were heard from pulpits of the district. Even University officials were reported to be sympathetic. While Wycliffe gave no direct support to the movement, his former secretary and friend John Purvey became a major leader in it. His closest colleague, Nicholas Hereford, actually departed for Rome to convince the Pope—and then recanted, probably to save himself, and returned to England as a Friendly Witness for the prosecution.

Condemned by the Archbishop of Canterbury, Lollardy was forced virtually underground in 1382. Wycliffe himself was driven from Oxford, and a number of his friends and supporters were arrested and compelled to recant. Wycliffe and his faithful followers, now scattered across England, no longer academic intellectuals, sometimes became evangelists and organizers. They had particular success in the East (where, according to some accounts, they later supported the tolerant York faction in the War of the Roses) and especially East Anglia (where, again according to some accounts, Cromwell drew some of his strongest support from Lollard traditions). But their effect reached still more widely, touching weavers (the actual, factory-working proletariat of the day), lower gentry, and farmers.

For a short time, sections of the royalty threw their support in this direction or, rather, against Rome, seeking the confiscation of Church property. Then the tide turned again, with the accession of Henry IV in 1399. The Lollard Bible was itself banned in 1407 and more former Oxfordites were arrested and threatened with a new statute of burning heretics at the stake. Some became martyrs in the next round of heresy-hunting, and finally the victors for the new Church of England. Meanwhile, an outright Lollard revolt, known as Oldcastle's uprising, was violently repressed. Its namesake, Sir John Oldcastle, was condemned, sent to the Tower of London, escaped, and became the most wanted man in England, until he was caught and burned alive in 1417.

Eleven years later, Wycliffe's bones were dug up and thrown into the River Swift. Underground and active, Lollards attempted another final revolution in 1431 and their influences continued in England under new names: anticlericalism and free-willism continued to emphasize vernacular readings of the Bible. A century later, this time in the name of the Church of England, local bishops were still sweeping communities with soldiers and informers seeking suspect Lollards; abroad, religious rebels were repeatedly accused of Lollardy for centuries.

In Christopher Hill's classic socialist interpretation of the events in *Puritanism and Revolution* (1958), the Lollards themselves have disappeared, but their impulses are very much alive in the English "Glorious Revolution" of 1640. Like Robin Hood of legend, the Lollards lived on in memory. Oliver Cromwell's army marched to battle singing hymns, and no one could accuse

the Levelers, let alone the ultraegalitarian Diggers, of not believing the deity was on their team.

In the centuries between Lollards and the Diggers, something had happened to Protestantism in England: in becoming the ideology of the rising middle class, it had shed nearly all of its radical character, even if the mass of ordinary people could be forgiven for not grasping this point. Protestantism, which had begun as a protest, was fast becoming a State religion, one that was likely to grow even harsher than its predecessor toward the growing classes of the dispossessed and potentially aggrieved.

Protests and spiritually based efforts to create a different vision of society naturally continued onward in other continents, forms and other times. A century and a half after the English Civil War, John Chapman a.k.a. Johnny Appleseed, a religious mystic on the American frontier, foreswore all violence and undertook personally to plant apple trees to bring the seeds (and fruit) of love to all. A major folk hero (or myth, like John Henry), Johnny was the bearer of a Radical Reformation that could not conquer capitalism's class and race divisions, but resolved to transform the existing order through personal efforts. Mythically armed only with a Bible and a bag of seeds, Johnny would bring an egalitarian and cooperative Heaven On Earth, if only he could.

The Shakers, a communitarian offshoot of the Quakers (or Friends), not only divided their property in common and sought to "recycle" all materials that they used, but also attempted something close to gender equality through celibacy and equal treatment. Their scattered communities survived in some cases into the twentieth century and their now-historic village settings still offer tourists a vivid picture of Bible-teaching that led to a peaceful, artistic way of life. The famed "Tree of Life," one of their popular iconic images, with sacredness at the center of the picture, would have been instantly recognizable in the village Mayday celebrations and evocations of Robin and Marian across large parts of medieval England. Likewise, for the radicalized villager, the Merchant who claimed control of the tree and stole the fruit—the original corruption of Eden—revealed himself as he charged for apples that had previously been free.

The prime successor to these religious-radical movements in our time has been seen in many places, including the Catholic Worker activists who (peacefully) assault nuclear weapons factories, or join with other religious and nonreligious people to protest the known centers of CIA activity aimed at Latin America and elsewhere. Liberation Theology, suddenly springing up during the 1970s and '80s, briefly swept across large parts of Latin America, urging an end to U.S. domination and to ecological depredation and the oppression of indigenous peoples. The short-lived "People's Church" of Nicaragua, cursed in the Vatican and drowned in U.S.-funded military assaults, remains a memory of what religious radicalism may do.

More widely, Protestants in East Germany (before the collapse of the East Bloc), in South Korea (against the U.S.-backed dictator), and in the English-speaking Caribbean, among other places, used Protestant church facilities and doctrines to seek justice and the replacement of state regimes. Interfaith progressive task forces, not to mention remnants of the Radical Reformation opposed to war in all its forms, still at this work today continue to carry on the spirit of old.

The religious response to the crises in the living conditions of the poor across the world today are naturally varied and often contradictory. Heavily funded evangelicals, preaching submission to the powerful and salvation only in the afterlife, often seem to be in charge of religious resources, along with their opposite numbers, arch-conservative Muslims just as opposed to women's rights but sometimes opposed to U.S. global domination as well. Still, the transhistorical saga of liberation is not over. Friar Tuck is safe from his State and clerical enemies, however, only in the deepest Greenwood, and within the traditions of intellectual ambiguity. Here and there (most deter-minedly in the 1950s television series *Adventures of Robin Hood*, written by Marxist intellectuals), Tuck is far more than a jolly comrade of Robin and friend of the masses. But he is never, in either body or spirit, aligned with the Sheriff of Nottingham.

William Blake, to return to E.P. Thompson's favorite, had sought to protect Christianity from such a fate of collaboration with the rulers, and to not allow the powers of religion (or faith) to be swallowed by some past events and personalities. He accepted the Deists of his own time for their battle against the power of priestcraft. But he insisted upon the importance of humans creating myths as a key faculty for individual and collective self-transformation. He perceived that the so-called "enlightened self-interest" of his time was the logic of self-serving liberalism. For Blake as for Thompson, love, emphatically including sexual love, held the promise of salvation. Love, Thompson insisted with Blake, was not something to be reasoned, but felt. Accordingly, embracing love was a romanticism large enough for global socialist revolution, although the realization of these hopes awaited the streets of Paris, 1968, to see inscribed in graffiti, "the more I make love, the more I want revolution, and the more I want revolution, the more I want to make love."

William Morris, for his part, was seeking to extract a kind of nature religion out of Christianity and to attach that nature religion to socialism as well as a larger vision of art, culture, and ecology.

Our Robin is both predecessor and successor, in different versions, to William Morris. As we shall see, Morris will create the British socialist move-ment by drawing deeply upon the traditions of the Greenwood and the strug-gle against rulers' designs to ravage flora and fauna alike for their purposes. There, where Robin survives, the seed of rebellion survives also, as a memory

of another, more cooperative way of life in the past and as a dream of finding that life somewhere in the future.

REFERENCES

Eric Hobsbawm, *Social Bandits and Primitive Rebels: Studies in the Archaic Forms of Social Movement in the 19th and 20th Centuries* (Glencoe, IL: The Free Press, 1959).

Stephen Knight, ed., *Robin Hood: An Anthology of Scholarship and Criticism* (Cambridge: D.S. Brewer, 1999).

Stephen Knight, *Robin Hood: A Complete Study of the English Outlaw* (Oxford: Blackwell, 1994).

William Morris, *Short Works of William Morris* (Charleston, SC: Bibliobazaar, n.d.), one of many published editions of "The Dream of John Ball."

E.P. Thompson, *William Morris: Romantic to Revolutionary* (Oakland: PM Press, 2011).

Lollards AND REBELS

BRITISH SOCIALIST ARTIST **WALTER CRANE**—VALUED COMRADE OF POET, SOCIALIST, PRESERVATIONIST AND ECOLOGIST **WILLIAM MORRIS**—REINVENTED AT THE END OF THE NINETEENTH CENTURY THE **QUESTION** ASKED BY **14TH CENTURY** REBELS. WHERE DID THE WEALTHY CLASSES GET THE **RIGHT** TO LIVE IT UP WHILE OTHERS SUFFERED? THAT IS: **WHO WAS RICH IN PARADISE?**

STORY - PAUL BUHLE

ART - GARY DUMM

HOW DID THE QUESTION ARISE SO **SHARPLY**, CENTURIES **EARLIER?**

WHEN ADAM DELVED AND EVE SPAN
WHO THEN WAS THE GENTLEMAN

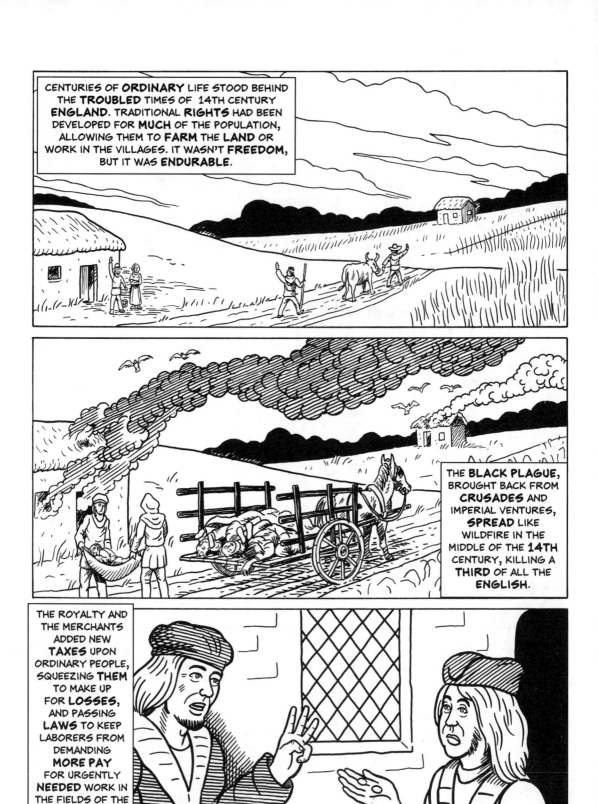

CENTURIES OF **ORDINARY** LIFE STOOD BEHIND THE **TROUBLED** TIMES OF 14TH CENTURY **ENGLAND.** TRADITIONAL **RIGHTS** HAD BEEN DEVELOPED FOR **MUCH** OF THE POPULATION, ALLOWING THEM TO **FARM** THE **LAND** OR WORK IN THE VILLAGES. IT WASN'T **FREEDOM,** BUT IT WAS **ENDURABLE.**

THE **BLACK PLAGUE,** BROUGHT BACK FROM **CRUSADES** AND IMPERIAL VENTURES, **SPREAD** LIKE WILDFIRE IN THE MIDDLE OF THE **14TH** CENTURY, KILLING A **THIRD** OF ALL THE **ENGLISH.**

THE ROYALTY AND THE MERCHANTS ADDED NEW **TAXES** UPON ORDINARY PEOPLE, SQUEEZING **THEM** TO MAKE UP FOR **LOSSES,** AND PASSING **LAWS** TO KEEP LABORERS FROM DEMANDING **MORE PAY** FOR URGENTLY **NEEDED** WORK IN THE FIELDS OF THE **LORDS.**

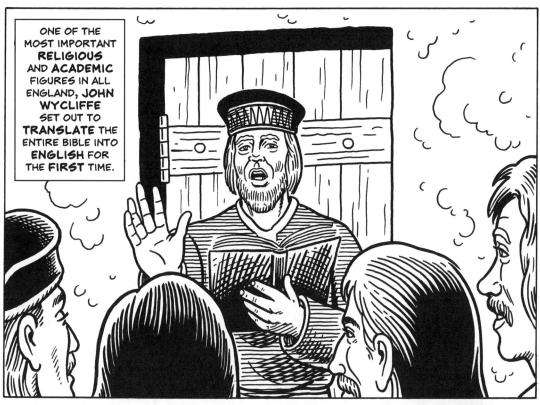

ONE OF THE MOST IMPORTANT **RELIGIOUS** AND **ACADEMIC** FIGURES IN ALL ENGLAND, **JOHN WYCLIFFE** SET OUT TO **TRANSLATE** THE ENTIRE BIBLE INTO **ENGLISH** FOR THE **FIRST** TIME.

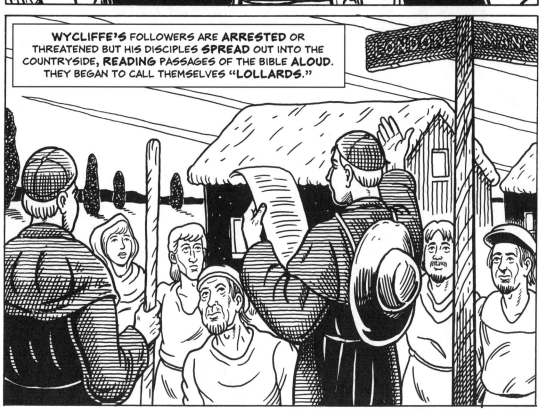

WYCLIFFE'S FOLLOWERS ARE **ARRESTED** OR THREATENED BUT HIS DISCIPLES **SPREAD** OUT INTO THE COUNTRYSIDE, **READING** PASSAGES OF THE BIBLE **ALOUD.** THEY BEGAN TO CALL THEMSELVES "LOLLARDS."

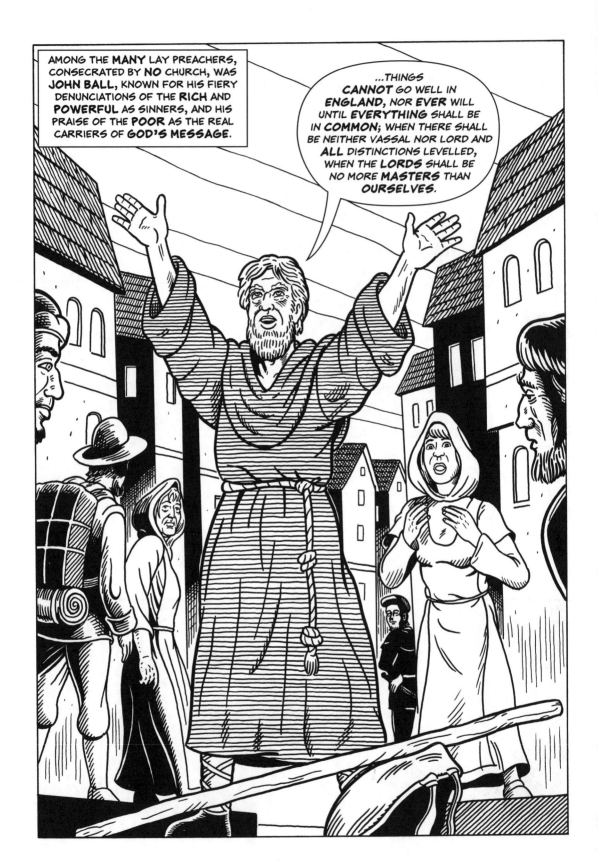

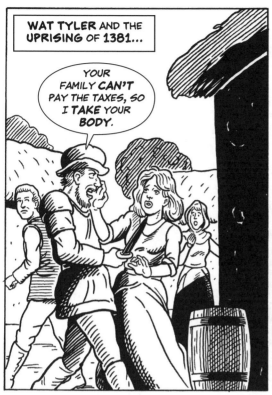

WAT TYLER AND THE UPRISING OF 1381...

YOUR FAMILY *CAN'T* PAY THE TAXES, SO I *TAKE YOUR BODY.*

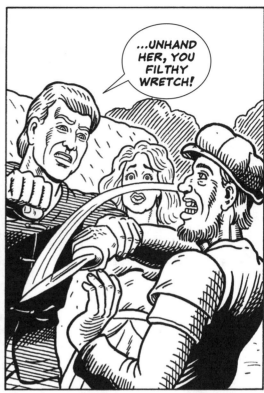

...UNHAND HER, YOU FILTHY WRETCH!

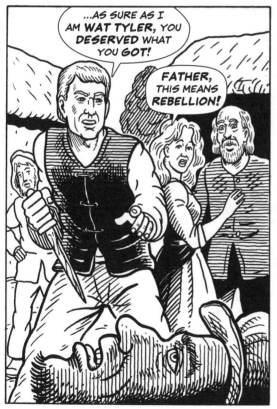

...AS SURE AS I AM *WAT TYLER,* YOU *DESERVED* WHAT YOU GOT!

FATHER, THIS MEANS *REBELLION!*

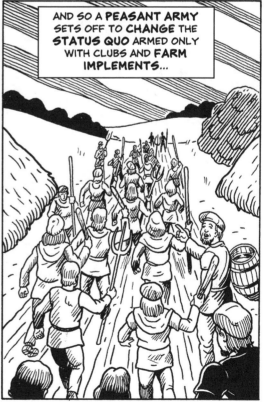

AND SO A *PEASANT ARMY* SETS OFF TO *CHANGE* THE *STATUS QUO* ARMED ONLY WITH CLUBS AND *FARM IMPLEMENTS...*

REVOLUTIONARIES **DESTROY** A CENTER OF THE **OFFICIAL** CHURCH, **HOME** TO THE **WEALTHY** CLASSES.

BY AN **AGREEMENT**, GREAT **CHANGES** WOULD BE MADE, AND THE **SAFETY** OF THE REBELS WOULD BE **GUARANTEED**. SO **WAT TYLER** MET WITH THE **16** YEAR OLD **KING**...

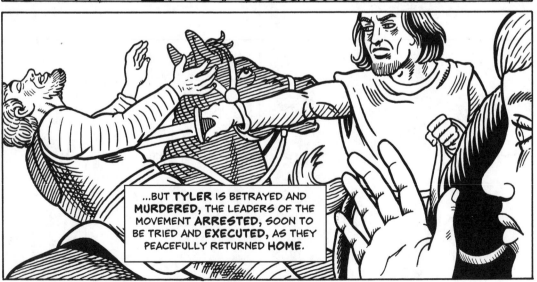

...BUT **TYLER** IS BETRAYED AND **MURDERED**, THE LEADERS OF THE MOVEMENT **ARRESTED**, SOON TO BE TRIED AND **EXECUTED**, AS THEY PEACEFULLY RETURNED **HOME**.

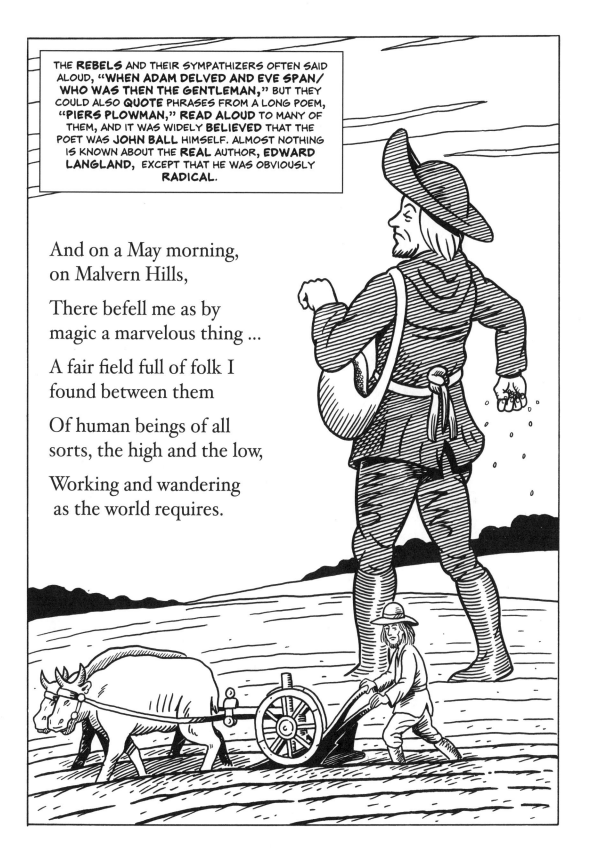

THE **REBELS** AND THEIR SYMPATHIZERS OFTEN SAID ALOUD, **"WHEN ADAM DELVED AND EVE SPAN/ WHO WAS THEN THE GENTLEMAN,"** BUT THEY COULD ALSO **QUOTE** PHRASES FROM A LONG POEM, **"PIERS PLOWMAN," READ ALOUD** TO MANY OF THEM, AND IT WAS WIDELY **BELIEVED** THAT THE POET WAS **JOHN BALL** HIMSELF. ALMOST NOTHING IS KNOWN ABOUT THE **REAL** AUTHOR, **EDWARD LANGLAND,** EXCEPT THAT HE WAS OBVIOUSLY **RADICAL.**

And on a May morning,
on Malvern Hills,

There befell me as by
magic a marvelous thing ...

A fair field full of folk I
found between them

Of human beings of all
sorts, the high and the low,

Working and wandering
as the world requires.

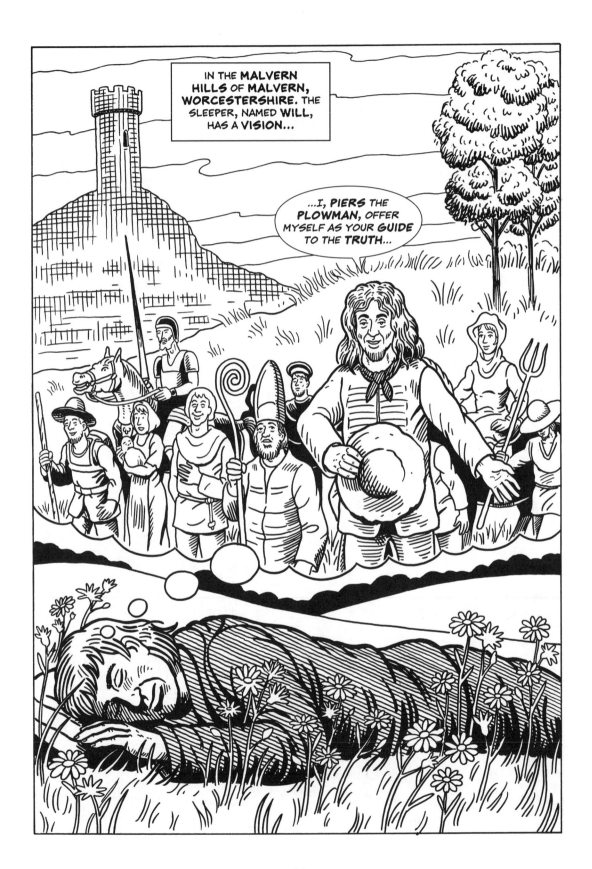

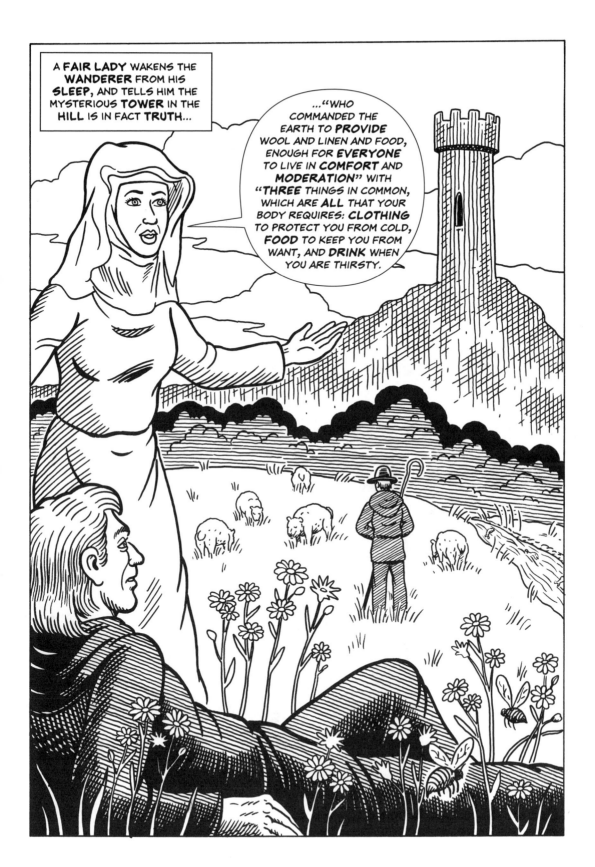

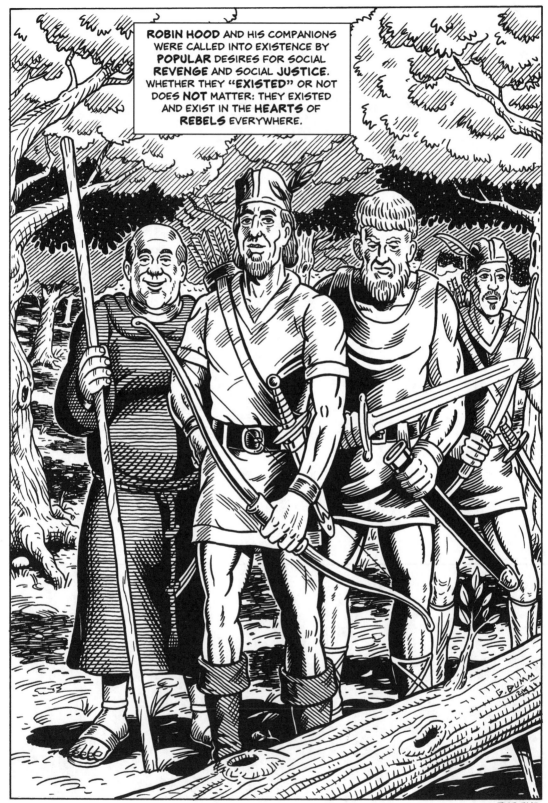

Revolutions and Poets: The Uprising of 1381, *Piers Plowman*, and the Robin Hood Narrative

"Empires only fall because a sufficient number of people are sufficiently determined to make them fall, whether those people live inside or outside the frontier."

—E.A. Thompson

Imperial crisis as social crisis: this is the central experience of the twenty-first century and not, of course, only for the West. Popular response can be measured and understood in many ways. It is helpful to look back seven centuries, decisive for our story. In a world where indigenous populations are pushed to the edge of nonexistence, along with the flora and fauna around them confronting malign "development" and resource exhaustion, the defense of the Greenwood gains a desperate relevance. Empire signals devastation and final evisceration, imperial crisis offers possible ways out, toward survival and more sustainable and cooperative ways of existing.

There are further, deeply intertwined developments—changes in society, religion, and culture—that create a presence for a Robin Hood, not only in the era of his challenge to authority (real or mythical), but in all the successive centuries leading up to the present. Mass uprisings and canonical texts offer indirect light but also crucial evidence of rebellion that more than a few of the devotees of Robin's Merry Men have long appreciated. For social historians of recent decades, with their emphasis on studying living conditions and modes of lower-class organizing, and for literary scholars with their emphasis upon printed culture, the social and literary aspects of revolution are not ordinarily seen together. For our purposes, the two are crucial to look at together as Robin's historical context. An analysis of the times in which his story leapt into being, the explosive social and intellectual movements, show why Robin Hood was needed, why ordinary people grasped at the myths around him, and why the sources of English literary (but not only literary) romanticism with so much influence on literature and art of modern times, are embedded in Robin's saga.

Scholar Ellen Meiksins Wood has made the argument, in *The Origin of Capitalism: A Longer View*, that English capitalism arrived early and advanced more rapidly in a few centuries than its Continental rivals, most of

all because English development simplified the class system. Those hiking (or rambling) trails that today's tourists love so much, passing through farmland and woods, exist because rural workers owned nothing and had to travel by foot to major estates carved out of previously common or at least communally used lands. When the time came for the surge forward to market dependence and overseas empire, the aristocratic resistance that held back imperial pioneers like Spain and Portugal had also ceased to weigh heavily in England. Capitalism was unimpeded, relatively speaking, but never unresisted. Robin Hood remained, even as the working class and other movements came to the fore in the twentieth century and beyond. The uprising of 1381 is the decisive backdrop for all this, and *Piers Plowman* the literary evidence for social unrest and the search for solutions, spiritual and otherwise.

Wat Tyler's Rebellion, 1381 AD

The uprising of 1381, the first major outbreak of a class and social conflict across England, foreshadowed the uprisings against Church and ruling classes of the next three or four centuries across the continents but also prepared the ground for the popularity of the Robin Hood saga. Wat Tyler's revolt was no mere expression of despair by the poor, but something closer to a real mobilization of people who had won some victories for themselves and their fellow villagers, and who thought of themselves as humans with rights. One of its typical mottos sums up much: "We are men formed in Christ's likeness and we are kept like beasts."

Those who participated in the revolt had more than a little in common with various figures among the Merry Men of Sherwood Forest. If they had not come back from some Crusade far away, many had in large numbers come back from fighting in the French war, using arrows against aristocratic officer-enemies as often as possible. They had brought, and kept, their own weapons.

To set the stage: throughout the near-constant conflict of European principalities against others, England had been preoccupied, for some time, attempting to extend their own power of kings and barons into their own back yards in Wales and Scotland. The Hundred Years War, however, was a different and rather new kind of conflict. King Edward III had pretensions of claiming the French crown, but also looked greedily at the wool industry in Flanders and the wine and salt (the latter as a base for iron-making) in Gascony as the real prize. Merchant capital, growing strong, aspired to unify everything political as a system, and to control the class conflict looming in Flanders, where some ten thousand weavers had held frequent strikes or uprisings since the middle of the thirteenth century. The rulers there, in frustration, had turned to the English king, who cleverly prohibited the export of wool to Flanders until his own ruling classes had agreed on a war policy.

In the wars that shortly followed, the French were able to effectively use gunpowder as well as develop a quasi-nationalist or "people's war" spirit against the invaders. For the first time, a new kind of cavalry was also being developed, suited for mobile operations, and also for the regularization of organization and pay for the troops. War was becoming industrialized. The use of the bow proved vital for a number of technological, strategic, social, and popular reasons.

The "golden age of archery" in England came and went with the fourteenth and fifteenth centuries. The longbow, used to shoot further and more accurately than any hitherto, had been perfected by the English and used to good advantage against the French, with many English archers recruited from the ranks of so-called poachers in the king's forest. Here was the weapon of the common man, requiring no special equipment except the bow itself, or training of outsiders; as the *hobby* of the common man, it was almost a national obsession. Quite possibly, the longbow served as a symbol of sorts for the yeoman coming into his own, still with few rights and little property, but more of each than his predecessors could claim. Along with Welshmen, the archers of Sherwood Forest were actually considered the finest, their skills on display at festivals and holidays with the encouragement of the monarch.

The centuries of archery coincided roughly with the creation of ballads, specifically outlaw ballads, in which Robin turns up from York through Scotland. Claiming themselves as free men of a free people, the balladeers were the defenders of the poorer classes, the powerless and unfree who looked upward one class for sympathy and aid. If Robin is indeed a dispossessed nobleman, as often hinted, then the yeomen likewise look up to him to assist those below.

The government, hard-pressed for cash, was meanwhile being looted by the nobility, utilizing the gaps between the badly faded Edward III, the child-successor Richard II, and the much-hated John of Gaunt, his uncle, and the chief patron of Wycliffe (who disapproved of the rebellion to come, but played no significant role in it). Moneylenders and tax specialists dug their claws into village life as never before.

This is also the backdrop for the Magna Carta in 1215, through which rebellious barons pressed King John to agree to sixty-three propositions elucidating the rights and privileges of the "freeman of England." While protecting the church, merchants, and aristocracy, the Magna Carta also recognized (if more indirectly than explicitly) the rightful presence and purpose of ordinary people as something beyond being mere servants of the powerful. Some of its provisions offered the beginnings of what would become, centuries later, trial by jury and rule of law, banning of torture and even habeas corpus. In an especially important measure, it banned the taking of crops without pay on the spot. Forests and rivers were nominally protected from takeovers and damming and, in a small but significant advance, even some

rights of widows were protected. This contributed to the belief that rights could be won and according to modern interpretations, the basis of claims rested both in ancient understandings of land use and the limits placed upon the monarchy by rising barons. Though royalty and merchants could and did violate the charter, its existence nevertheless raised the hopes of the powerless and weakened the self-confidence of the monarchy.

At least one more crucial factor lay behind the uprising of 1381: the appearance of Black Death. As bubonic plague passed from the continent and the East to parts of England, it wiped out whole villages, perhaps a third of the existing population in all. As a result, disorganization of the whole economy, particularly agriculture, was inevitable. There was a sharp rise in prices for commodities, and successful demands by agricultural workers for better pay and conditions of work. In 1350, parliament met this threat with a new Statute of Laborers that outlawed the movement of agricultural workers from farm to farm or region to region, as well as the demand for any wages higher than before.

The lords could not effectively compel acceptance of these rules, and repeated efforts at enforcement proved unsuccessful. Meanwhile, peasant cultivators who tenanted lands drove better bargains on the calculated value of their services, and some serfs successfully fled to towns or found more generous lords. With the rise of a migratory class of peasants and workers, the old rules of the village community (and often enough the community itself) were eroded if not destroyed. The lords responded with extended terms of tenure and other new arrangements that moved farming closer to the modern system in which the personal relations of the lord and laborer were broken down and replaced by a money relation.

Meanwhile, parliament was hard at work with further legislation revealing the lords' anxiety and downright fear. A statute of 1377 describes how the poor (or "villains") "do menace the ministers of their lords in life and member, and ... gather themselves in great routs and agree by such confederacy that one should aid the other ... much the harm do they do," by deed and example, to their lords. That is to say: self-made agitators informed gatherings of workers to not to take less than a certain amount, sixpence or eightpence, when the lawful pay had been set at twopence or threepence. Among the agitators and supporters were honest jurists and manorial officials who customarily traveled and could spread news and share strategies.

These gatherings began to call themselves "The Great Society," a phrase later borrowed often (including Lyndon Johnson's 1960s update of the New Deal programs) but in the early Middle Ages, inevitably connoting something as much within existing customs as something hoped for in the present or future. English as well as local "society" and its history belonged to them, not only to the aristocratic and powerful, and greatness would be realized not by foreign conquests but by reaffirmation of the common good.

It is not surprising, then, that guild organizations known as "hundreds," devoted since the distant past to mutual benefit and sometimes dedicated to a local saint, were often the natural mechanism for organizing resistance and revolution. In Essex, a center of the revolt, mobilization came from someone also important enough to compel local officials to maintain living standards, offering archers their usual rate of pay, sixpence per day, rather than a forced reduction. Elsewhere, insisting that they had a commission from Wat Tyler, leading men of Kent organized twenty villagers to burn the coroners' and tax collectors' records and forbade tenants from paying levies for the upkeep of the lords. (Spanish anarchists, six centuries later, burned local records for similar reasons: nothing of the dead past of oppression could safely be left behind to be recovered and used against the villagers.) The revolt was well rooted locally, providing a strong element of its tenacity.

Some recent British historians, arguing that the rebellion could not possibly be understood as class conflict (while admitting no other description quite fits either), point to the wide range of people articulating and leading the rebellion—as if revolutionary ideals could not be articulated and carried through by a sympathetic minority of the educated population and other radicalized members of upper classes. Articulated in religious terms, the rhetoric of the uprising was nevertheless revolutionary. Even when framed or explained by elements of the local elites, it was aimed firmly against the rulers in parliament, the nobility, gentry, and upper-crust clergy. John Ball preached that "matters goeth not well to pass in England nor shall do till everything be [held in] common and that there be no villains nor gentlemen but that we may all be united together and that the lords be no greater masters than we be." He determined to prove, according to a contemporary, that "from the beginning all men were created equal by nature and that servitude had been introduced by the unjust and evil oppression of men against the will of God." More revolutionary words would hardly be heard in that century, or perhaps any other.

The deterioration of social conditions further forced the hands of the rulers, prompting new levels of injustice. Despite public discontent, the Court of Common Pleas (the civil court, as opposed to the Court of King's Bench, the criminal court) decided early in the fourteenth century that it "didn't have time for the affairs of peasants." Civil disputes of various kinds remained unresolved, and Parliament allowed Commissioners to remove judges and settle cases in their own personal favor. The poll tax, assessed at between four pence and a shilling per family, may have been the final straw in weeks and months before the uprising.

In spring of 1381, villagers in South Essex attacked and killed a collector of taxes. According to a rather more picturesque tradition claimed for Kent, Wat Tyler initiated the revolt when a certain tax collector, insisting upon his right to determine taxable ages of the young, reputedly stripped Wat

Tyler's daughter naked and sexually assaulted her. Tyler, a craftsman working nearby, smashed the skull of the assailant with a hammer. His neighbors not only cheered but drew courage: across western Kent, they came together and elected Wat their leader, and joined the men of Essex.

This assembling group found another, guided by the two other personalities of the story, John Ball and Jack Straw. So little is known about Tyler, Ball, and Straw that we may wonder at how these ordinary people, a craftsman and two itinerant preachers, should find themselves, in such leading roles. Ball, at least, had a record: he had been imprisoned, in the 1360s, for illegal preaching, which is to say preaching outside accepted Church (and State) rules. He and Jack Straw were examples of the kind of typical low-level priests who, by their degree of literacy, familiarity with the Bible, and sense of social life, were seen as the most dangerous of rebellious intellectuals. Ball, in a sermon, reworked from earlier popular versions the famous phrase,

> When Adam delved, and Eve span
> Who was then the Gentleman?

In other words, the Garden of Eden had no social classes, and a future heavenly garden would have no need of an aristocracy, either. By this standard, classes and privileges were artificial and wrongful.

Similar thoughts must have inspired others of the same ilk in assorted villages. According to a contemporary observer, one Thomas Baker (his name identical with his trade) of Fobbing "took courage and began to make speeches," encouraging others to seek out "friends and relatives . . . from village to village, district to district, seeking advice and asking them to bring prompt help with respect to those needs which they had in common and which bore so heavily on them." And so they gathered in larger crowds "with a great show of jubilation, as was their wont." Five centuries and some later, Lenin would call revolutions "festivals of the oppressed," and these oppressed obviously felt festive. With Fobbing's people leading the way, bands of seventeen other Essex villages joined the rebels.

It is probable that the rebels had advanced knowledge that apprentices and journeymen of London would join them as they marched toward the city on June 7. Perhaps they even knew that slum-dwellers, many of them ordinary laborers and families driven from their rural homes, would happily join. A few sections of prosperous London including two aldermen offered support. Thursday, June 13, London Bridge opened to accommodate the marchers; there was no royal resistance, and estimates of numbers ranged up to one hundred thousand, a huge number for the time.

Together, they attacked parliamentary and law offices, burning buildings, going after certain individuals known for pressing tax claims and setting up "man traps" to catch those who sought to evade being dispossessed by

legal judgments. The hated John of Gaunt's palace of Savoy was among those burned, and the Chancellor himself was executed.

It is notable that rioters were forbidden, by common consent, from stealing valuables; trinkets found were burned or otherwise destroyed. When a trapped and surrounded King Richard II asked them what were their demands, they answered simply, "We will [that is, wish to] be free forever, our heirs and our lands."

Peter Linebaugh has gathered the anecdotes of the most remarkable dialogues in English history to that date or, perhaps, ever. A monarch was forced to converse as equal with an egalitarian revolutionary leader and the king "asked him what were the points which he wished to have considered, and he should have them freely and without contradiction, written out and sealed. Thereupon the said Wat rehearsed the points which were to be demanded; and he asked that there should be no law except for the law of Winchester . . . and that henceforward there should be no outlawry in any process of law, and that no lord should have lordship in future, but it should be divided among all men, except for the king's own lordship."

Tyler further demanded that the goods of Holy Church should be divided among the people, except for those needed to maintain the clergy. Lands and buildings would be taken from the bishops, prelates, parsons, vicars, and other churchmen. He demanded no more villeinage and no serfdom, leaving the king with a mere crown and title. The king seemed to agree.

Satisfied, Tyler had a drink of water, then ale, got on his horse, and rode away . . . into an assassination. Slain by order of the king, stabbed repeatedly so as to die a painful, miserable death, Wat perished. Men with longbows readied themselves for battle, but Richard confused the masses by declaring Wat a traitor to their cause, and himself their true champion. Shortly after, the soldiers closed in on the crowd.

Without their leader, not knowing what to do next, the marchers headed homeward. Richard ordered some 1,500 hanged, after rigged trials run by a judge who warned juries he would hang them if they did not reach the desired verdict. It seems a small consolation that the judge himself was hung seven years later.

In the 1840s, British Chartists could still be heard singing:

For Tyler of old,
A heart-chorus bold,
Let Labour's children sing

Meanwhile, the rebellious impulse spread to the continent.

The German Peasants' War was only one successor to the uprising, but a useful one to consider. In the last half of the fourteenth century, labor shortages in Germany had permitted peasants to sell their labor at higher prices and acquire some additional legal improvements. The threat of a return to

the worst of serfdom came at a time when other social classes, including some guildsmen and even aristocrats, had begun to question the legitimacy of existing authority. The *Bundschuh* Revolt (named for the shoes that poor men wore) during the first twenty years of the fifteenth century coincided with religious dissent and the Reformation, just as Lollard or Wycliffite impulses had intersected with the Wat Tyler Rebellion.

Jan Hus, the Wat Tyler of Central Europe, was condemned by the Church and executed in 1415. Objections by regional knights and nobles to this act prompted the Holy Roman Emperor to threaten that he would drown all Hussites and Wycliffites, viewing the two rebellious sects together as a subversive "international" foreshadowing, from our viewpoint, the international radicalism of future generations. Local citizens of Bohemia drove Catholic priests from their parishes. The fighting destroyed much of Prague, with Hussites throwing notable magistrates out the window. Successfully fighting off their enemies, they held ground from 1419 to 1434 before being crushed. The Roman Church then returned to power—something that most ordinary Bohemians, including future Czechs involved in various socialist, anarchist, communist, and postcommunist movements never accepted as legitimate.

No one would say that Robin Hood was ever-present in these movements, yet the spirit of his resistance could not have been absent.

Piers Plowman

As the Great Society was projected toward revolt, one of the purposefully cryptic messages going from village to village spoke of "John Nameless and John the Miller and John Carter, and biddeth them that they beware of guy in borough, and stand together in God's name, and biddeth Piers Plowman goew to his werke and chastise well Hob the Robber, . . . and look sharp you to onehead [unity] and no moe [more]."

Piers Plowman thus advanced from literary personage into political life. Piers chastised one particular thief and fiend, the Treasurer of England, who indeed was put to death in real life. The now-famous poem was clearly known to the marchers, who made their own use of it. They could have hardly suspected, however, that the allegory was destined to be one of the recognized classics of English literature along with Chaucer's *Canterbury Tales* (indeed, in some early printed editions of the latter, *Piers Plowman* was tucked in as a sort of appendix). An earlier and more avowedly political poem, "The Evil Times of Richard II," usually dated to 1287, was merely a complaint, without the hints of millenarianism.

Little is known about the poet of *Piers Plowman*, William Langland, who seems to have arrived in London with his wife in a state of poverty, scraping along by delivering recitations and prayers (the wealthy classes paid for these well done), and by begging. Fifty-seven manuscript versions

of the poem have survived, almost a third of them dating before 1400. The poem was meant to be recited: it was by nature a creation of oral culture, preceding the age of print by more than a century. It was certainly recited and talked about enough for the name Piers Plowman to be taken up by the insurgents in 1381. Like the Wycliffe Bible, translated at approximately the same time, *Piers Plowman* most likely evolved or at least traveled through the passing of manuscripts around; as in the case of the Lollards, it likely involved guarded speech, the mumbling or muttering contents that could be dangerous to the speaker.

The poem begins:

> And on a May morning, on Malvern Hills,
> There befell me as by magic a marvelous thing . . .
> A fair field full of folk I found between them
> Of human beings of all sorts, the high and the low,
> Working and wandering as the world requires.

The fair lady waking the speaker informs him that a Tower on the hill is in fact Truth, "commanded the earth to provide wool and linen and food, enough for everyone to live in comfort and moderation" with "three things in common, which are all that your body requires: clothing to protect you from cold, food to keep you from want, and drink when you are thirsty."

It goes on:

> Need, who knows no law and is indebted to no one. For to keep alive, there are three things which Need takes without asking. The first is food; for if men refuse to give him any, and he has no money, nothing to pawn, and no one to guarantee him, then he seizes it for himself. And there he commits no sin, even if he uses deceit to get it. He can take clothing in the same way, provided he has no better payment to offer; Need is always ready to bail a man out of prison for that. And thirdly, if his tongue is parched, the law of his nature ['the lawe of kynde'] compels him to drink at every ditch rather than die of thirst. So in great necessity, Need may help himself, without consulting Conscience or the Cardinal Virtues—provided he keep the Spirit of Moderation.

Linebaugh names these the "themes of hierarchy and class composition," concerning workers in the field and workers in the town, not to mention those who wander without work. At the time of *Piers Plowman,* perhaps over half of the English population was small-holders, some owning plow teams and those hiring themselves out. Consequently, the problems of this society greatly concerned the price and terms of labor power.

In an era when last names were only beginning to be firmly established among ordinary people as a consequence of property issues and patriarchal claims, anonymity also counted heavily. Collectivity, a mirror of an older

society but also a means of protection from being identified and jailed or killed outright, was obligatory and even "natural." From another angle, in a society where many last names were taken easily from occupations, "Jack the Miller" could be any number of skilled craftsmen. Thus, in John Ball's letter, Jack the Miller says, "Look thy mill go aright, with the four sails, and the post stand in steadfastness. With right and with might, with skill and with will, let might keep right, and skill go before will and right before might, then goeth our mill aright. And if might go before right, and will before skill, then is our mill mis-adight." The machine, as Linebaugh argues, will be appropriated by the collective.

The manuscript versions of *Piers Plowman* were available amid the 1381 uprising, and printed version appeared two centuries later during the times of revolts against enclosures. Kett's Rebellion in the east and the Prayer Book Rebellion in the west may be said to have called Piers Plowman into existence as a poetic standard in the language.

Better remembered than this history, at least for British school students, has been text of the iconic poem itself. The very first literary mention of Robin Hood is found in the 1377 text of the allegory, the protagonist of which is the common plowman who willingly gives himself over to spirit voices and guidance in pursuit of the ultimate Christian faith. He has many human weaknesses to overcome, daunting in their effects upon the quest for a better (and then, best) way. It is tempting to glimpse here something like "the answer to the riddle of history that knows itself to be the answer," to quote the young Marx. Indeed, Piers is unriddling a history that knows unhappiness best, trying to reach beyond history to something else not easily encompassed in theological terms (or outside of them, either).

Scholars have fairly placed *Piers Plowman* within the religious imagery of the City of God, offering love as the bond of everything, faithful to the Divine rather than human law (but who held the secret to God's law? That would be a Lollard question). The realm of the Supreme is impossible on earth (thanks, or properly no thanks, to Original Sin) but Langland argues that spiritual renewal can and must come, not only for Piers but for everyone. Langland, then, belongs to the group of millenarian thinkers like Joachim of Fiore and Mechthild of Magdeburg who inspired Jakob Boehme, famous recuperator of the Dialectic (lost since the Ancients) and forefather of German romanticism as well as an important philosophical influence upon Hegel and Marx, among others.

The reference to Robin in *Piers Plowman* is a strange one. A priest called Sloth famously confesses that whilst he can't always remember his prayers, he can recite all the ballads of popular heroes:

> I kan nought parfitly my Paternoster as the preest it singeth
> but I kan rhymes of Robyn hood and Randolf Earl of Chester

That is: I do not know my Paternoster perfectly, but I know rhymes of Robin Hood and Randolf Earl of Chester.

Whether he is "Slothful" because Sloth is merely lazy, or because he is disillusioned with the Church and leaning toward popular culture for his sense of what religion means remains uncertain.

Whatever the case, the religious connotations here are no simple matter. Once firmly in power, Protestants of the Church of England turned with a vengeance upon the remnants of Robin Hoodery. Control of Mayday festivals by the parish were reoriented to abolish the old quasi-egalitarianism of the Church of Rome, in which high and low, equally frail and short-lived, were equal in the eyes of the Almighty. The idea of equality, thereafter, became increasingly conflicted and troublesome.

Authorities wanted nothing of the Robin Hood, Lord of Misrule.

REFERENCES

T.P. Dunning, *Piers Plowman: An Interpretation of the A-Text* (London: Longsman Green, 1937).

Rodney Hilton, *Bond Men Made Free: Medieval Peasant Movements and the English Rising of 1381* (London: Routledge, 1973, 2003).

Rodney Hilton, "Origins of Robin Hood," *Past and Present* 14 (November 1958).

Peter Linebaugh, "Wat Tyler Day," *Counterpunch*, June 13, 2008, http://www.counterpunch.org/2008/06/13/wat-tyler-day/.

Lois Potter and Joshua Calhoun, eds., *Images of Robin Hood: Medieval to Modern* (Newark: University of Delaware Press, 2008).

E.A. Thompson, "Peasant Revolts in Late Roman Gaul and Spain," *Past and Present*, no. 2 (November 1952).

George Macaulay Trevelyan, *England in the Age of Wycliffe, 1368–1520* (New York: Harper Torchbooks, 1963).

Ellen Meiksins Wood, *The Origin of Capitalism: A Longer View*, 2nd ed. (New York: Verso, 2002).

In old England there was a youth who often day dreamed of mythical times when his ancestors danced and played. A time when the entire day was spent being merry in the Greenwood. A dreamer in these oppressive days is sure to run afoul of the King's laws. These laws were enforced by the relentless and greedy Sheriff of Nottingham.

And so the legend of Robin Hood, people's outlaw and forest hero, is retold to embolden those dreamers who will stand up to injustice wherever it exists.

48

Sherwood Forest was bountiful with creatures of all varieties. None were so nutritious as the King's deer. But killing the King's deer came with a noose.

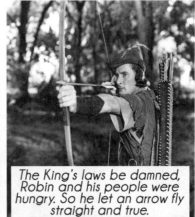

The King's laws be damned, Robin and his people were hungry. So he let an arrow fly straight and true.

SWOOSH!!!

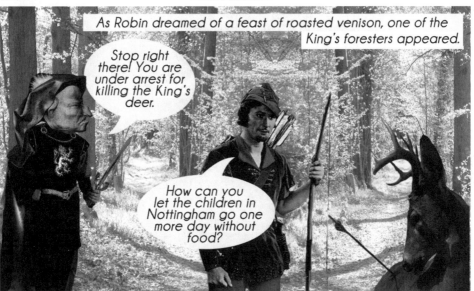

As Robin dreamed of a feast of roasted venison, one of the King's foresters appeared.

Stop right there! You are under arrest for killing the King's deer.

How can you let the children in Nottingham go one more day without food?

Before the forester could answer Robin smote him with a mighty blow to the jaw. The forester turned and ran to gather reinforcements.

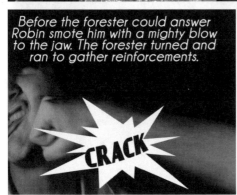

CRACK

The forester told the sheriff and was hanged for his incompentence. The sheriff issued the same sentence to Robin.

The peasants thought, "A special place in Hell is reserved for a man with the cruelty and greed of the Sheriff of Nottingham."

curses!

Robin evaded the sheriff's men by wearing a hooded cape. He survived by begging for food and singing lusty tunes.

At this time the King of England had committed his army to the Crusades in the Holy Land. Finding it difficult to replenish his ranks, the King issued a decree to pardon any man from his crimes so long as he joined joined the Crusade in Jerusalem. Robin made his way to the coast and boarded the next ship to Palestine.

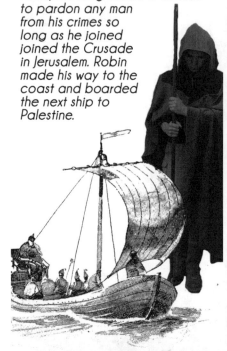

Robin fought boldly in battle. However, he despised the King's treatment of the Muslim captives. Massacres of women, children and the elderly were not un-common. The orders came directly from the King. During one battle Robin was taken captive. He tried not to imagine the cruel punishment he was to receive.

Instead a certain affinity de-veloped between Robin and his prison guard. He was surprised to learn that he shared more in common with the Muslim guard than he did with the King and nobility of England.

Eventually the guard brought books and taught Robin to read and write.

When sufficient time had passed Robin was released. He promised to not raise a sword or bow agaisnt the common man for as long as he lived.

Robin had decided that it was better to be an outlaw than to continue fighting in the King's tyrannical army.

So Robin returned to England. Yet again an outlaw of the Hood promising to fight the injustice of evil men.

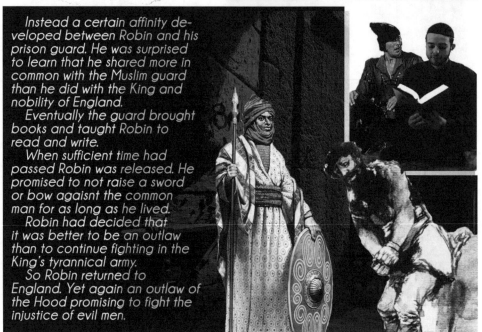

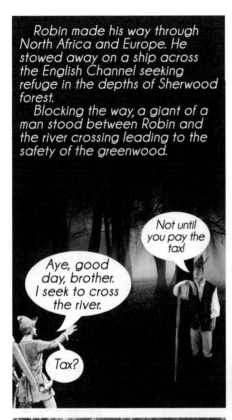

Robin made his way through North Africa and Europe. He stowed away on a ship across the English Channel seeking refuge in the depths of Sherwood forest.

Blocking the way, a giant of a man stood between Robin and the river crossing leading to the safety of the greenwood.

Not until you pay the tax!

Aye, good day, brother. I seek to cross the river.

Tax?

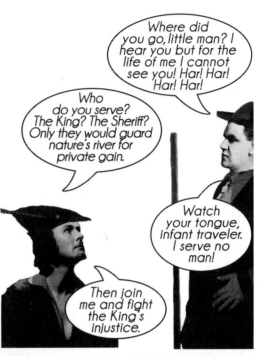

Where did you go, little man? I hear you but for the life of me I cannot see you! Har! Har! Har! Har!

Who do you serve? The King? The Sheriff? Only they would guard nature's river for private gain.

Watch your tongue, infant traveler. I serve no man!

Then join me and fight the King's injustice.

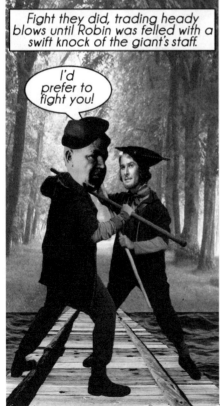

Fight they did, trading heady blows until Robin was felled with a swift knock of the giant's staff.

I'd prefer to fight you!

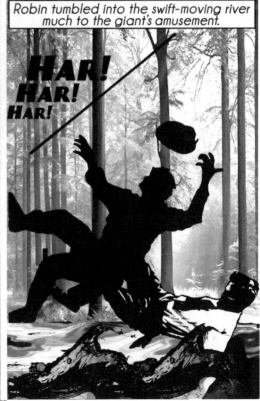

Robin tumbled into the swift-moving river much to the giant's amusement.

HAR! HAR! HAR!

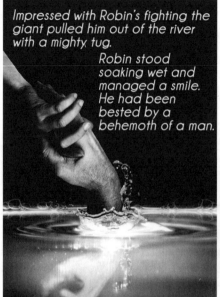

Impressed with Robin's fighting the giant pulled him out of the river with a mighty tug.

Robin stood soaking wet and managed a smile. He had been bested by a behemoth of a man.

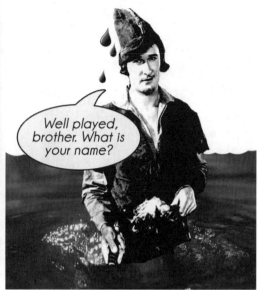

Well played, brother. What is your name?

Robin had a good laugh at the giant's expense. The giant named John Little tolerated Robin's humor. However, it was Robin's ideas of reclaiming the land for the people that captured his imagination.

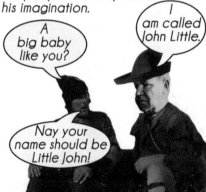

A big baby like you?

I am called John Little.

Nay your name should be Little John!

The two walked and discussed how they could organize others to fight the Sheriff and challenge the King's claim to the land.

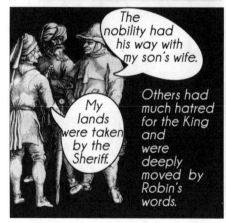

The nobility had his way with my son's wife.

My lands were taken by the Sheriff.

Others had much hatred for the King and were deeply moved by Robin's words.

Shall we be bound by oppression?

NAY! NAY!

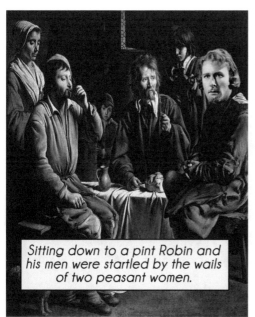

They spoke at length about horrible acts of violence because people could not pay the extraordinarily high taxes set by the King. The Sheriff sent his men dressed with horrible demon masks to plunder, pillage and terrify the people.

Sitting down to a pint Robin and his men were startled by the wails of two peasant women.

I just can't go on like this. How many will have to die?

Robin decided now was the time for action. He told his men to give the signal.

The ram's horn sounded the alarm. Robin and his comrades fought the sheriff's henchmen.

Victorious in battle and defending the rights of the commoner, Robin gained the trust of the people and soon his band grew.

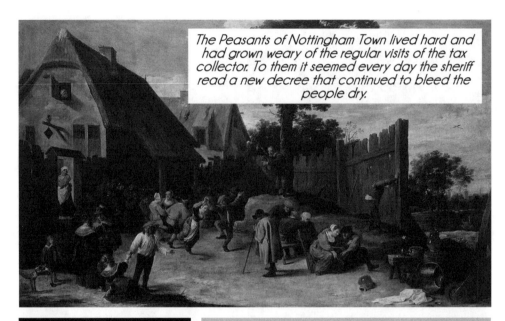

The Peasants of Nottingham Town lived hard and had grown weary of the regular visits of the tax collector. To them it seemed every day the sheriff read a new decree that continued to bleed the people dry.

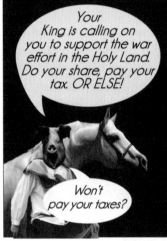

Your King is calling on you to support the war effort in the Holy Land. Do your share, pay your tax. OR ELSE!

Won't pay your taxes?

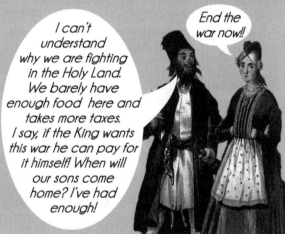

I can't understand why we are fighting in the Holy Land. We barely have enough food here and takes more taxes. I say, if the King wants this war he can pay for it himself! When will our sons come home? I've had enough!

End the war now!!

No one strummed a merrier song than young Will Stutely. While Robin's merry band enjoyed a song from Will, a husband and wife rushed forward.

Where's Robin?!?

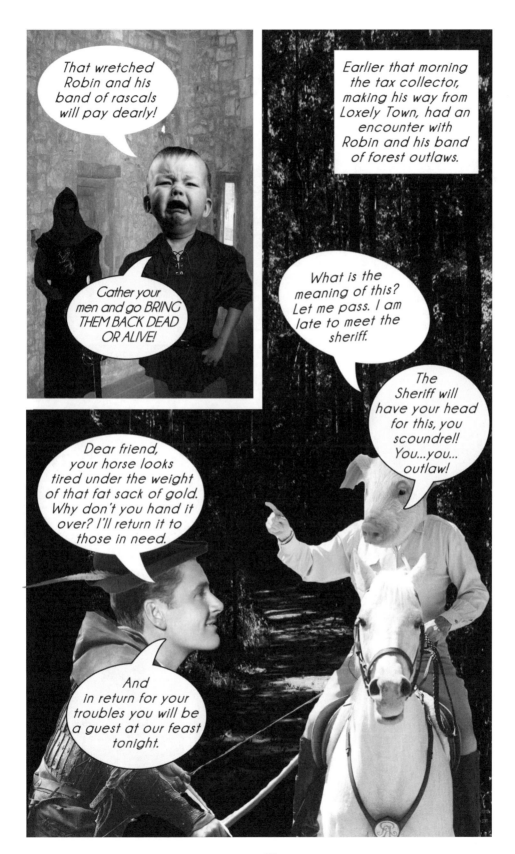

The feast was a raucus good time with drinks, food and games of all types.

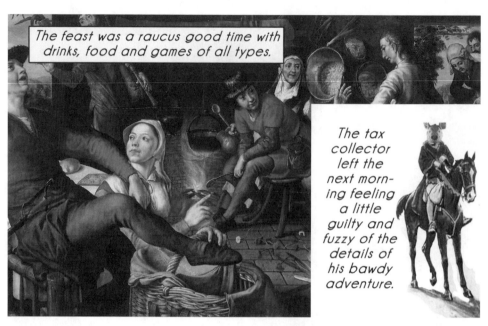

The tax collector left the next morning feeling a little guilty and fuzzy of the details of his bawdy adventure.

Will Stutely went hunting early in the morning, thinking that the forest was clear of the sheriff's men.

He was bold and brash and bagged one of the King's deer. This morning his carelessness would be his undoing.

The camp was still asleep when Little John woke Robin.

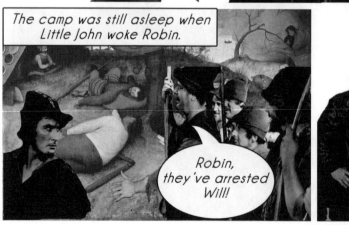

Robin, they've arrested Will!

The Sheriff pondered what to do with his new guest...

56

CHAPTER 3

Robin Hood, Media Man

138A.1 COME listen to me, you gallants so free,
 All you that loves mirth for to hear,
 And I will you tell of a bold outlaw,
 That lived in Nottinghamshire.
 That lived in Nottinghamshire.

138A.2 As Robin Hood in the forrest stood,
 All under the green-wood tree,
 There was he ware of a brave young man,
 As fine as fine might be.

138A.3 The youngster was clothed in scarlet red,
 In scarlet fine and gay,
 And he did frisk it over the plain,
 And chanted a roundelay.
 — "Robin Hood and Alan a Dale" [i.e., Robin gets
 his first minstrel], *Childe Ballads*

From its first representation as local ballads to its climax on big and small screens, Robin Hood was born for media culture. We often forget that through the preliterate, vast majority of Homo sapiens's time on earth, ballads and fireside stories have filled the space that television, film, radio, video games, and reading matter of all kinds now occupy. As original oral history, ballads— poetry accompanied by music and dance—told the story of the tribe, the community and later the nation. The ballad not only helped insure the continuity of the community, but also, it was believed, of Nature's bounty. The ballad reflected and reinforced a supposed natural order.

Robin Hood, the saga, emerged in England at a time of bitter social conflict and was reshaped continually by the modernizing forces of order and production. The medieval barons who ordered playlets performed by singers and actors would not, of course, wish Robin to be a *social* bandit—a romantic bandit certainly, but not one with a social cause. Nor would most of the playwrights have wished to pursue such themes. Village populations across England and Scotland hosting Mayday carnivals around Robin Hood, with many references to pre-Christian fertility rites, symbolically turned

the social order upside down for a day. But these cheery events also served the well-loved (or well-connected) locals who often waited years to get the key parts in the drama: Robin, Marian, Friar Tuck, and several of the notable Merry Men, all dressed in their Greenwood finery and lauded by their neighbors on the occasion. While these populations may have been rebellious-minded, they acted within a set celebratory rather than rebellious framework.

The Robin Hood ballads could not, however, have been created without the rebellious legends with their antiestablishment emphasis casually reinforced in musical entertainments as carnival-like games, and without the presence of the very real social unrest sometimes taking place alongside these presumably innocent activities. According to Norfolk court records from 1441, laborers and yeomen once blocked a road and sang "We arn [are] Robynhodesmen war war war," and threatened to kill a distinctly resented local member of the nobility, most likely because he had taken away some preexisting right. Three generations later, one Staffordshire citizen defended himself in court of leading a riot under the name of Robin Hood. Having been joined by a priest and a hundred villagers, he claimed to be merely a leader of an entertainment misunderstood by authorities. Two hundred men assembled and threatened to release him from jail violently, then relented. How many more of these local incidents went unreported, we are not likely ever to find out.

Some of the earlier ballads put forth Marian as stand-in for the Virgin Mary, with Robin as her defender who protects the sacred forest from unwanted changes. Faithful Catholics, reacting against the imposition of Protestantism, were surely looking for such a figure. But as Queen of May (with Robin as King), Marian was also a fertility figure far from virginal. Early ballads were also likely to portray Robin as the forester with a mysterious power in his archery, a forerunner of the "Old West" hero with a six-gun in hand. These semireligious portrayals overlapped with musical entertainments and recitations that stressed manly violence in the forest (for example: beset by drunken louts, Robin shoots all of them dead with his bow) and bawdy tales of Robin and his outlaws fighting authorities, all with sex and outhouse jokes on the side. The *Childe Ballads*, assembled near the end of the nineteenth century, had no fewer than thirty-eight Robin-centered ballads, all featuring contradictorily gentle and violent Robin Hoods. Audiences (and singers) clearly chose what they liked.

A Lyttell Geste of Robyn Hode, the first well-circulated, printed version of the saga by an unknown author or editor collecting assorted tales, was published in late fifteenth century and subsequently printed and reprinted seven times by the middle of the sixteenth century. It is a landmark work in its own right, bringing into a single narrative five verse-tales ("Robin Hood and the Knight," "Robin Hood and the Sheriff," "Little John and the Sheriff," "Robin Hood and the King," and "The Death of Robin Hood") and

thus creating a kind of encyclopedia of Robin-ness—the canonical source, until Ritson's work, for a variety of adaptations.

In the *Geste*, Robin instructs Little John that the poor should be protected while those in authority should be shown no mercy:

> But see you do no farmer harm
> that tills with his plough
> Neither the good yeoman
> that walks by the greenwood shade
> Nor no knight or squire
> that will be a good fellow
> But these bishops and these archbishops
> You shall beat and bind
> And the High Sheriff of Nottingham
> Keep him on your mind

Consequently, historian Stephen Knight concedes that "*The Gest* advocates massive theft from the church, civic insurrection against and murder of a properly appointed Sheriff, breach of legitimate agreement with a king." Certain that other versions of Robin should be set against this one, Knight, following J.C. Holt, also reminds the reader that localism of a purportedly conservative kind (resistance against the commercialization of life with its cash nexus and heightened geographical mobility and contact) seemed to have a particular hold on plays and games at the time. Robin Hood, then, represented the local unhappiness with unwanted changes, though some elements of the population most likely took part in enacting those changes while consoling themselves through symbolic defenses of fading ways. Other scholars suggest that Robin may represent the heroic, rising merchant class against decadent royalty, a favorite theatrical theme for centuries.

The idea of a more conservative Robin was certainly understandable as an official project aimed at erasing a dangerous Robin. Worried by the impact of the games, the Scottish parliament officially (if unsuccessfully) banned celebrations in 1555. A few years later, a figure no less eminent than John Knox complained that in Edinburgh, "the rascal multitude were stirred up to make a Robin Hood, which enormity was of many years left off and condemned by . . . act of parliament. Yet would they not be forbidden, but would disobey and trouble the town."

From the late sixteenth and seventeenth centuries onward, the transformation of Robin on stage was more successful at vanquishing the legend of the social rebel, at least in some aspects. First, it exaggerated physicality at the expense of context: London audiences wanted the outlaw drama and used Robin or a Robin-like substitute for anything at hand. Robin, then, was a champion Englishman in a nationalist-minded England that had defeated the Spanish Armada. In this treatment, Robin may have been a nobleman

unsuited to brawling, or himself a low-class brawler, or only a useful support actor in some past regional conflict. He was most likely both a superathlete and a secret aristocrat—an interpretation closer to the film version three centuries later, Robin swinging from chandeliers and fighting off dozens of the Sheriff's men with sword or bow.

According to Knight, the "merryness" of the Merry Men followed the same trajectory on stage. Neither grim nor especially oppressed, they (like Robin) mostly represent a time slipping away or gone entirely, the simpler day of honest peasants and yeomen living in a pleasant folk culture of their own making. The worse the urban chaos of the present seemed, the better the rural past, in the neopastoral art of collective nostalgia. The Elizabethan Age (and its court-sponsored theater) further banished rebellious Robin, replacing him with a benign figure who rights wrongs but also recognizes a social threat when he sees one.

But perhaps things are not so simple and straightforward: the description of peasantry and Old England as "conservative," a view shared by future liberals and most Marxists alike, for generations, may be highly misleading. In a conservative setting, even a simple rascal who shuns normal life for the joys of the forest represents a kind of rebellion. Thus, *Real Robin*, a comedic playscript dated 1661, can be seen as a comedy with purpose. This is obvious, in part, with the ways that the playwright prepares the reader or audience:

> No danger unexpected to a mind
> Prepar'd to meet the worst that it can finde.

And later:

> Enter little John and Shierfs Messenger [Robin Hood is on hand]
> ROBIN: Speak, what's the news?
> JOHN: Gives and Fetters, Hatchets and Halters, stincking prisons and the death of dogs is all we can expect.
> ROB: Why, what's the matter?
> JOHN: Tis the Kings Coronation; and now the Shiereffe with a band of armed men, are marching to reduce us to loyalty, and the miseries of an honest life.

In short: Robin and his not-so-merry men are on the run, outcasts anticipating persecution, with only one alternative to rebellion. They would be forced to live their lives subserviently, obeying laws, turning over their output to the lords, in short, merely surviving, without prospect of freedom or adventure.

The appearance of the single-sheet broadside, the commercial production of songs or poems, sold at fairs and markets by peddlers and hawkers, adds several more dimensions to our understanding of the meanings that ordinary people gave to Robin and his rebelliousness. In some ways the original (printed) popular culture reflecting the tastes and desires of the public,

"songs" become any popular verse, even if we do not know whether they were "sung" or meant to be recited aloud. Printed versions for sale, Robin Hood broadsides, may have appeared before the seventeenth century, but a flood of them commenced from 1624 onward.

These broadsides may contain mostly old stories now written down, or new stories written for an emerging market, but it is clear that new songs, meant specifically for musical use, were increasingly produced for old tunes unrelated to Robin Hood, with stylized patterns developed for musical patterns and meter as in other popular music of the age. Their verses may strike today's scholars as verbose and repetitive; heard aloud, however, they had such a grip on the public that "outlaw ballads" sung in the nineteenth-century British countryside had been little altered from some two centuries earlier. Robin had staying power. Not that Robin, the character, was necessarily unchanging. In the process of adaptation, Robin seemed to become at times more of an urban hero waging contests of skill with workmen who sometimes outwit him. And here, he also became sometimes more comical.

From the eighteenth century onward, readers began to encounter Robin in cheap anthologies (including the *Robin Hood Garland*). These "chapbooks," or crudely printed little volumes, could run as long as eighty pages but more often were twenty-four pages long and included illustrations especially profuse in somewhat more pricey editions.

But who bought them? Because broadsides, and then chapbooks, sold more briskly in towns and cities than rural zones, their audience was likely to be the urban lower classes, perhaps recent migrants from the countryside seeking jobs and for many, freedom from the old bonds of rural life. Sometimes, they would have been men and women driven from the villages by the ongoing enclosures. These readers in particular wanted entertainment but they also nurtured the legacy of rebellion, and probably their own sense of nostalgia for the beauty and quiet of the rural scene.

Such contradictions, but also the pure glory of Robin, spilled out into the work of Joseph Ritson's *Robin Hood: A Collection of all the Ancient Poems, Songs and Ballads, now extant, Relative to that Celebrated English Outlaw: To Which are Affixed Historical Anecdotes of His Life*, published first in 1795.

Ritson himself was a literary rebel. A wild enthusiast for the French Revolution (and unlike some of England's leading poets, never willing afterward to repudiate its legacies) and a bitter critic of the Roman Church as well as its English counterpart, Ritson was above all a collector and an early archivist, and a highly intelligent one at that. His *Robin Hood* quickly became the most influential interpretation of the Robin legacy for generations of scholars, combining previous stories and adding a gloss of his own. His citations, notes, and illustrations from original texts of historical fiction and nonfiction accounts must be considered, for the day, an extraordinary accomplishment.

For Ritson, they were best understood within the context of contemporary radicalism.

Ritson established Robin's qualities through an almost psychological study of the available folkish documents: "just, generous, benevolent, faithful and believed or revered by his followers or adherents for his excellent and amiable qualities." Ritson also argued for the historical existence of a nonfiction Robin Hood, an Earl of Huntingdon who "in a barbarous age, and under a complicated tyranny, displayed a spirit of freedom and independence which has endeared him to the common people" against all the efforts of "titled ruffian and sainted idiots, to suppress" his true story. This was quite a claim, and not one easily heard in an England where defeat of the French and anxiety about "revolution" became predominant sentiments. After 1815, as economic crisis merged with imperial crisis, Ritson's *Robin Hood* emerged as the accepted classic version, along with folkloric inclusion of Robin stories in the *Childe Ballads* collected and published during the last two decades of the nineteenth century.

Ritson hardly touched upon one complication related to so many issues of conflict and rebellion in European and North American society the "Jewish Question." As outsiders but also armed with an unusual degree of education and certain financial skills, European and Euro-American Jewish populations have contained an abundance of rebellious, even revolutionary souls, but also wealthy conservatives who seek to dominate their own community and quash the rebels. For these reasons along with the ever-present anti-Semitism, Jews have often found themselves trapped between various threatening forces, and Britain is no exception. In a few early versions of Robin Hood lore, the dusky-skinned, somewhat mysterious Maid Marian may even be Jewish. As in so many other folk tales buried in more modern social history, especially notable in labor history, she may have rebelled from her own wealthy parents, fallen in love with a handsome Gentile revolutionary, and devoted her life to his cause.

A related angle on Robin's social role emerged when the hugely successful novelist (and romanticizer of Scottish lords), Sir Walter Scott, crafted an imaginary *Ivanhoe* (1819) as a Robin-type character for his homeland. It was a brilliant literary stroke, if (like most of Scott's work) a mainly conservative one. Here, Robin's literary other (Robin himself also appears curiously in *Ivanhoe* as a secondary character) has become a version of Sir Lancelot or the Scottish Rob Roy. But in a society given to aristocratic anti-Semitism, Scott's novel may have been the first major, sympathetic treatment of Jews to that point, suggesting that they epitomize the new urban, commercial class distant from the chilly aristocrats. His Rebecca, the Jewess (played by the bosomy, future real-life Jewish convert Elizabeth Taylor in the Hollywood hit filmed in the United Kingdom but scripted by Marguerite Roberts, a left-wing blacklist victim who lost her film credits), draws the curiosity, love, and definitely the lust of the protagonist, although she must die so that he can

wed the fair *shiksa* of noble blood. This was another old theme, resting on at least one historical fact: the Jewish community lived in and around York, and although brought over by the Normans (thus, presumably the enemies of Saxons) nevertheless lived precariously, the financial agents and merchant-servants of the throne that might always turn against them, and did.

Scott seems to have plucked the basis of this story of Jews and Christians out of local lore. As early as 1632, Anthony Munday had published *A True Tale of Robin Hood*, in which Robin shockingly castrates a bishop and wages violent war with the Church that despises the Jews and incites attacks upon them. One of the very first plays banned by the new Puritan leadership, *A True Tale* thus presents Robin as the good friend and Gentile benefactor of the Jews. His colleague Friar Tuck may, indeed, have been borrowed from the real Bishop of Lincoln in the late twelfth century, remembered as a special friend of the Jewish community. Folklore about one Suleimann, a Moor befriended by Robin, likewise appears in the *Childe Ballads* along with tales of the Jewish children protected against the Sheriff of Nottingham by Robin. According to legend, a very real Sheriff of Nottingham launched a pogrom on local Jews, but failed for lack of support.

According to some versions, a semimythical King Richard (there were three King Richards within a couple of centuries), unlike Robin's supposed ally not so good, had demanded money for the Third Crusade and learned that the Jews were none too eager to give him resources to assault their own people in the Holy Land. Returning to England and faced with irate Jewish leaders, he purportedly ordered them attacked. He did not succeed in his pogrom, but Jews and women were reputedly banned from his coronation. Still more myth-making is evident here: Jews were, in fact, expelled from the British Isles in 1290 under Edward I.

In the same century as the hawkish Sir Walter Scott, the poet John Keats expressed the popular revulsion at war. His 1817 poem explored the impact of blood and money on nature and humankind, looking to Maid Marian and Robin:

> And if Robin should be cast
> Sudden from his turfed grave
> And if Marian should have
> Once again her forest days
> She would weep and he would craze
> He would swear, for all his oaks
> fallen beneath the dockyard strokes
> Have rotted on the briny seas
> She would weep that her wild bees
> Sang not to her—strange that honey
> Can't be got without hard money

We leave the pastoral, Green Robin for the next chapter of this book, but it is worth noting that Robin was increasingly an object of the occasional poet with a social conscience. Editor-poet Leigh Hunt, publishing "Ballads of Robin Hood" in his own magazine in 1820, essentially updated and uplifted the ballads. Robin thus tells a common farm worker and millwright as he gives them gold coins taken from the rich,

> Well, Ploughman, there's a sheaf of yours
> Turn'd to yellow gold
> And, miller, there's your last year's rent
> 'Twill wrap thee from the cold.

Nineteenth-century novelists reaching for the wide audience of "yellow back" pulps produced a murkier Robin, as likely to be involved in court intrigue as supporting an imagined leader who brought the Magna Carta into existence against the will of royalty. The most popular writer by far, Pierce Egan, was a pulp master of medieval melodrama who had achieved great success with *Wat Tyler*. He published *Robin Hood and Little John or the Merry Men of Sherwood* (serialized from 1838, published in 1840) of some four hundred pages. Full of illustrations, it proved to be both a children's book and one aimed at adult buyers, revealing no political leaning by the author toward either radicalism or conservatism. Indeed, that last point may have been its strength: the dashing Robin was effectively freed from social roots and limitations.

Robin of the Victorian stage inevitably became a swashbuckler and nostalgia-laden figure of premodern (preindustrial, preurban) times, followed swiftly by Robin the champion of liberal ideas at the turn of the century, and then by a small flood of Robin Hood children's books (i.e., books aimed chiefly at the customer-parents of middle-class children), hardly known before 1870, in the early years of the new century. Socially speaking, this was a sanitized Robin, no real threat to the social order.

Robin on the contemporary Victorian/American stage offered another mediocre variation upon the original. In 1890, American composer Reginald De Koven wrote and managed to stage an otherwise undistinguished comic opera, save for Robin sharing a duet with Maid Marian, "O Promise Me." Somehow, it fit the mood of wedding ceremonies of the time perfectly and never disappeared from the repertoires. Why Robin? Because he was always available, ever adaptable.

Howard Pyle's *Merry Adventures of Robin Hood of Great Renown in Nottinghamshire* (1883) was a genuine innovation, albeit in form more than content. Robin material had only begun to appear in the United States at this time, and Pyle had a growing reputation for his illustrated children's books. It has been suggested that the author's native rural Delaware bore a resemblance to Sherwood Forest, and his Quakerism contained a dissenting

sensibility (not, however, much of a pacifist limitation). Pyle's writing has been described as "spare," a description that also fits his drawings, but with something extra: Pyle's fascination with the Pre-Raphaelites. His earlier success, *The Lady of Shalott*, had borrowed heavily from the work of British socialist and Pre-Raphaelite Walter Crane.

Williams Morris's fascination with Pyle's *Merry Adventures* makes good sense because it was close to Morris's own spirit, and in line with the heavy praise that Pyle's book received in the literary circles of 1880s London. One can almost feel the Morrisian medievalism, romantic poetry and all, in Pyle's prose:

> Five score or more good stout yeomen joined themselves to him, and chose him to be their leader and chief. Then they vowed that even as they themselves had been despoiled they would despoil their oppressors, whether baron, abbot, knight, or squire, and that from each they would take that which had been wrung from the poor by unjust taxes, or land rents, or in wrongful fines . . . to many a poor family, they came to praise Robin and his merry men, and to tell many tales of him and of his doings in Sherwood Forest, for they felt him to be one of themselves.

This was a medievalism reinvented, however, quite as much as Damon Runyon was to invent an argot for horse players, chippies with golden hearts, and so on, two generations later. Pyle wanted to send his young readers into a place that only their imagination could carry them.

No small part of this was Pyle's sense of nature lore: In the "merry morn" of the forest, where "all the birds were singing blithely among the leaves," Robin finds adventure, and the natural setting is never far from sight. It is also, or can be seen to be, all part of the grand saga of England, Robin a necessary outlaw but a friend to the Good King Richard, defender of the proper throne. This was schoolboy stuff, as Pyle himself might have calculated, but schoolboy stuff of a superior sort. The book has been in and out of print, mostly in print, for every generation after its writing.

Among Pyle's successors were his students, illustrators Charlotte Harding and N.C. Wyeth (more painterly and also more hackishly sentimental than Harding or Pyle), who captured Greenwood scenes with verve and in the case of Wyeth, in full color. Unlike Pyle, they were not authors and did not actually seek to recast the saga; their Robin Hood books could not live up to the continuing popularity of the master.

A more typical successor, distinctly inferior, is the *Aldine Robin Hood Library* published in London shortly after the turn of the twentieth century, in dozens of volumes, with what has been described as "text-based narratives [that] resemble comic books" even without the panel drawings. Cheap in every sense and a successor to pulp novels but now aimed more precisely at kids, they were reissued following the film version by Douglas Fairbanks.

Hereafter, books were more likely to build upon the success of films rather than vice versa.

There was one magnificent successor to Pyle, in the depths of the British and American Depression: *Bows Against the Barons* (1934) by Geoffrey Trease. The author, evidently sympathetic toward the Communist Party of Great Britain, distanced himself from left-wing politics in his later years, but could not disguise the class-conflict narrative of the original. But the book was bowdlerized in the Cold War era, the text watered down and the illustrations wholly redrawn from his incendiary children's original, in which Trease's Robin is a lad on the run from the king's men who joins the Merry Men and lives with them in the Greenwood until they take part in a revolutionary uprising that is brutally crushed. Here they learn that "there are only two classes, masters and men, haves and have-nots," and they express the vision that an "England . . . without masters" may be realized somewhere in the future, although not in Robin's time, and tragically not by the outlaws who call each other "comrade." Trease's following book, *Comrades for the Charter* (about the Chartist movement), showed the struggle's next step into modernity.

Another children's text was by the far more famous. T.H. White's *Sword in the Stone* (1938) has Robin as "Robin Wood" along with his usual comrades, now strangely in King Arthur's time. For White, Robin is "the spirit of the woods he lives in."

Robin and the Movies

Pyle had in a sense predicted the takeover of Robin by Americans, especially those in Hollywood. Robin Hood as cinematic hero took the field at least twice in the 1910s, but in full force with Douglas Fairbanks in 1922. Fairbanks moved acrobatically around one set after another, sword-fighting and then in deadly hand-to-hand combat, swinging from chandeliers, swimming through moats and all the other stunts that Mel Brooks would lampoon in *Robin Hood: Men in Tights*.

The Fairbanks version, true to the tale of the nobleman assisting the oppressed but also pledging himself to King Richard, was also important in at least one other narrative respect: romance. Filmmakers had already grasped the significance of the female lead, especially for the sake of women in the movie audience. In this version, Marian is determinedly virginal (Robin, making his escape from a tower and promising that his men may save her soon but perhaps not soon enough, lends her a dagger to use on herself . . . just in case) and panic-stricken at her worse-than-death potential loss. Everything about Marian depends upon Robin: no innovation here. But there is more to be said, if only because of the film's continuing cinematic importance. Robin Hood became and still remains a Hollywood phenomenon as the social rebel beloved of the ticket-buying masses.

The first motion picture *ever* to have a publicized Hollywood premiere, elaborately staged at Grauman's Egyptian Theatre on October 18, 1922, *Douglas Fairbanks in Robin Hood* was also one of the most expensive films yet made. Fairbanks himself, under a pen name, adapted the screenplay from a novel, and had built a faux-twelfth-century Nottingham castle-village at the Pickford-Fairbanks Studio. Sets, some designed by Frank Lloyd Wright's son, Lloyd Wright, followed the logic of director Allan Dwan, who was himself an important modernist set designer. Releasing company United Artists, a company owned by Fairbanks, Pickford, Chaplin, and Griffith, bet its fortune on this project—and won.

Only a still more remarkable film could out-do Fairbanks's silent classic. *The Adventures of Robin Hood* (1938), costarring a heart-rending Olivia de Havilland as Maid Marian, amplified a wealth-redistributionist Robin Hood generally absent from the Fairbanks version. Leading man Flynn, reputed to be an early 1930s pro-Fascist but always more interested in chasing women (all four services turned him down for wartime duty, because he had heart problems but also numerous venereal diseases) and boozing, was soon to become the anti-Fascist screen hero several times over. Before the end of his life (at fifty), Flynn pronounced himself, on prime-time television, to be a drinking buddy of Fidel Castro's, that other romantic Robin Hood-style hero, although insisting that they had never talked politics.

Meanwhile, playing Maid Marian, de Havilland was perfection. The noblewoman, at first resentful and politically conservative, is won from her aristocratic beliefs by Robin's showing her the misery wrought by the Norman occupiers. She follows her heart and her political growth step by step into romance and partisanship. Very much her own person, this Maid Marian is on her way toward a crypto-feminism of self-assertion, leaving behind nothing in the heart-throb department.

It is safe to say that the Errol Flynn's Robin has never left the popular imagination—or the imagination of money-calculating filmmakers—for very long. During the summer of 2010, with the newest Robin epic on the screens, Flynn's *The Adventures of Robin Hood* was reshown in public parks, or on walls against the background of "Early [English] Music" festivals, and in assorted other revivals high and low, as well as getting a bounce in video stores (the DVD set is rich in extra "features").

What else had made this iconic version a huge and lasting hit? Apart from Robin and Marian, there is the notable camaraderie of the Merry Men, but also notably the stark evil of the authorities. The Sheriff of Nottingham, as played by Basil Rathbone, means to wipe out all opposition. He is a Fascist, whatever he happens to call himself. As darkness swept over contemporary Europe, it was easy to identify those like him in charge of the threat to decency, and their connections with the powerful ruling groups of various nations.

As late as 1938, outright anti-Fascist films were still practically forbidden, thanks to the unwillingness of Hollywood's moguls to lose the German or Italian markets, but after Pearl Harbor, the plot detail of a noble anti-Fascist was not at all unusual. Among dozens of such films, *In Our Time* (1944), directed by the affable progressive Vincent Sherman and cowritten by future blacklist victim Howard Koch, was fairly typical. It stars Ida Lupino as an upper-crust Englishwoman married to a Polish aristocrat played by Paul Henreid. As the war is about to come to them, the foreign lady—Lupino herself happened to be a left-leaning actress from an Italian stage family, later married to another graylisted progressive, Howard Duff—joins her husband in preparing the modern-day peasants for resistance, facing, as the film closes, either life in the underground or certain death themselves. Even aristocrats could be good, although there were plenty of bad King John types occupying roles as Nazi sympathizers in such left-wing films, clinging to Fascism to protect the last of their aristocratic privileges from unwashed democrats, let alone communists. This film, unlike many others of the time, needed no modern Robin of forest lore.

Meanwhile, Errol Flynn the actor provided historical metaphors (*Sea Hawk*, 1940, written by Howard Koch) with the swashbuckling freebooter Sir Francis Drake warning the Queen against the plotters secretly supporting the Spanish Armada; and *Edge of Darkness* (1943, written by left-winger Robert Rossen) featuring Flynn the British guerilla aiding the patriotic Resistance against the murderous Nazis in one Norwegian village. This last fictional hero in particular made himself into the great ally of real-life Communist Partisans, fighting fearlessly behind enemy lines across Europe, as true Robin would surely have done.

A pair of movies written or cowritten by Melvin Levy (a Communist who like Rossen later became a reluctant Friendly Witness, naming names in a desperate and unsuccessful attempt to save what remained of his career) offer yet more radical evidence about Robin types in Hollywood. The first of these is *Robin Hood of El Dorado* (1936), one of the most spectacular anti-racist films of a film era in which these were rare and mostly limited to sympathetic treatment of individual Indians. A highly fictionalized biography of Joaquin Murieta, the famed social bandit who took to the hills to fight the invading Anglo land-grabbers, finds the "yankees" looting and robbing the poor Mexicans in mid-nineteenth-century California. His encampment, a center of merriment, dancing, singing, as well as military training for a guerilla army, was the best update of the Sherwood Forest guerillas in modern cinema to the time. He first aims to rob the rich Mexicans who have treated his own family so badly, and then learns that they, too, have been expropriated. A daughter of that class takes up arms with him as a lover and cofighter, but as the guerillas plan to escape to Mexico and safety, they are gunned down to the last member by ruthless, murdering Anglo creeps.

The second, *The Bandit of Sherwood Forest* (1946), so named because the Robin Hood title was being held back by the studio, would perhaps have been more properly named "Son of Robin Hood," since the charismatic hero is that swashbuckling screen idol Cornel Wilde (who advanced to the U.S. fencing team for the 1936 Olympics but quit to take an acting part). Dad/ Robin has been fighting off the Sheriff while son is off to the Crusades. Father and son together lead a near-revolt against the treacherous regent of the Crown, who aims at nothing less than murder of the child who would become King . . . and destruction of the Magna Carta in the process! Aged Robin Hood urges his followers onward with a ringing "Comrades, I call you together again because the people of England face a grave crisis. . . . Together we will fight the new tyranny," an unmistakable reference to the Fascists still never far away from the public mind. Meanwhile, the evil regent explains to a group of his fellow aristocrats, "The people are not fit to rule themselves. Therefore I am withdrawing the Magna Carta. . . . From now on the people will be taxed like they should be taxed, and ruled as they should be ruled." Freedom is never assured, and must be fought for again and again.

Among several other postwar Robin films, the otherwise mediocre *Rogues of Sherwood Forest* (1950) has an evil king determined once again to take back the rights won in the Magna Carta, and Robin stealing the tax money collected by the king's henchmen. Supported by the Archbishop of Canterbury, Robin wins the right for every Englishman to "dispose of his own property by will."

The huge-cast, history-based swashbucklers made in Hollywood in those postwar years probably also raised the bar for Robin Hood-style der-ring-do. *Quo Vadis, Demetrius and the Gladiators,* and *The Robe* among them were met if not matched by lower-cost English-based productions like *Rob Roy, the Highland Rogue; The Sword and the Rose;* and *The Knights of the Round Table.*

If another model were sought in a single film, it would surely be *The Flame and the Arrow* (1950), scripted by Waldo Salt, as noted above. Resemblances here to the secret branches (or cells) of the recent anti-Nazi Underground were unmistakable. Alternatively, in *Captain Scarlett* (1953), written by blacklistee Howard Dimsdale, a dispossessed noble returns to France to find Royalists squeezing the poor, now that the Restoration has taken hold and he fights back for the masses! The clock was winding down on left-tinted guerilla, anti-Fascist themes, but they would reappear amid the disillusionment with Vietnam. Such films might have existed without the Robin Hood narrative; it is certain that they could not have been as compelling.

By contrast, the Disney version, *The Story of Robin Hood and His Merrie Men* (1953), although Disney's first major live-action adventure, was mere standard Cold War fare. Critics would later point out that, here, Robin's

noble ancestry reached its clearest identification, as did his defense of property. Twenty years down the line, an animated Disney version had Robin as a fox—a conscious or subconscious reversal of the methods by which the real-life persecuting Roman Church cast the Lollards as wicked foxes among geese, the faithful but naïve masses of common folk.

And Television

Ironically, the repressive mood of the 1950s prompted the most watched Robin since Errol Flynn and even a half-century later, arguably the best Robin of all. A live-action television failure *Robin Hood* (1953) lasted only one season. It was succeeded in two years by the real thing, a television show with a most remarkable backstory.

The Adventures of Robin Hood (1955–59), with intermittent reruns in the early 1960s, was created and shot in Britain, likely the only place that it could have been done. Its producer was American Hannah Weinstein, a former theatrical lawyer (and organizer of major events for the doomed Henry Wallace/Progressive Party campaign of 1948) who saw the writing on the wall and like many of the victims of the Hollywood blacklist made up her mind to create a career abroad. In Britain as in France, the blacklistees were welcomed as heroes, notwithstanding the British government's slavish acceptance of U.S. foreign policies, military, and intelligence operations across the planet.

Weinstein easily made contact with blacklisted screenwriters living in New York, Hollywood and Paris. The most important, by a long stretch, was Ring Lardner, Jr., who until the witch hunt had been regarded as one of the film colony's brightest young talent, as well as Katharine Hepburn's personal favorite. He slipped downward after *Woman of the Year* won him an Oscar, but *Forever Amber* (1947) provided a hint of Lardner's true inclinations. In a quasi-historical costume drama about the Cromwell era, a lively gamin played by Linda Darnell jumped from lover to lover amid other adventures. Despite political and sexual censorship, it was a "strong woman" film with side jabs at the hypocrisies of history's wealthy and privileged classes.

Lardner, Jr., and his longtime film collaborator Ian McLellan Hunter were set to work with young script editor Albert Ruben in London, devising a system—prompted by blacklistees' inability to obtain passports—by which he traded story ideas and scripts across the Atlantic. This resulted in some of the best, wittiest, and most political writing on television in an era of live drama and other experimentation rarely seen again until film and cable competition drove networks onward to risks political and sexual alike. (Along the way, Lardner wrote *MASH*, the film destined to symbolize a public turn against the Vietnam War, and to provide the plot for the most peacenik, popular, and ultimately most rerun television show of the century—*M*A*S*H*).

From Hollywood, Weinstein and Ruben could count on former writer-producer Adrian Scott and scriptwriters Waldo Salt, future scriptwriter for *Midnight Cowboy*, and Robert Lees, an Oscar winner for comedy shorts of the 1930s and a top writer for Abbott and Costello until the blacklist struck home. Slated to script *I Love Lucy* (Lucille Ball was a reliable "progressive" who evaded blacklisting because her sponsors arranged a successful evasion), Lees was a perfect television writer as he later proved through *Lassie*, *Flipper*, and *Daktari*. Still another small group of political refugees worked on Robin scripts from France. It was a high talent team, to say the least.

Weinstein made it work through financial ingenuity, a staging method that required only minimal expenses, and by virtue of buying the talent of Richard Greene, one of the most dashing heroes on the British scene. Greene had proven himself to the theme in *Captain Scarlett*, costarring Nedrick Young, who had been slated to be "the next Errol Flynn" when the blacklist fell upon him. Set designer Peter Proud, more keenly aware of television's visual limitations and possibilities than anyone else in his position, created moveable scenery, trees, bushes, and cottages, saving the expenses of the show for all other considerations. Seen even now, *The Adventures of Robin Hood* looks less hokey, less reliant upon familiar time-filler action scenes than television adventure shows to the middle 1970s and beyond.

The Adventures of Robin Hood fairly set the small screen afire. It quickly attracted thirty-two million viewers on both sides of the Atlantic. It also drew upon the knowledge and insight of historical scholars, in this case British scholars, offering examples of the use of existing laws in the High Medieval Ages to protect commoners against the worst abuses that aristocrats sought to hand out. With the careful oversight of Ruben, it made for consistently clever, sometime hilarious viewing: the dialogue was snappy and socially conscious (especially from Maid Marian) and the bad guys were bad enough but also capable, now and then, of doing the right thing, as when a forest fire or a psychopathic baron brought the foes together in common cause. More often, Robin and his Men, joined by Marian, typically protected an old woman accused of being a witch (i.e., the ongoing witch hunt in the United States); conducted a secret mission to France and joined hands with the French Underground (shades of anti-Nazi activities); provided aid to Friar Tuck, who was being a People's Priest in resisting Pope and Sheriff; or frustrated the tax-man or the hangman, for the nth time in the series.

Like the widely reputed first "quality" television show by Americans, *You Are There* (written by another team of blacklisted writers, close friends of the Robin Hood team, and produced in kinescope versions for public school classrooms), it was also an unforgettable slap in the face of the repressive 1950s. More, it represented the struggle to get beyond them. Together, these shows offered history as a way of learning, and as mass culture created with a skimpy budget afterwards unimaginable.

An effort to bring this success to the big screen did not succeed. *Sword of Sherwood Forest* (1960) starred Richard Greene in his swashbuckling best and was shot in the Irish countryside, but dropped the blacklisted writers and with them, the social content of the stories. Little remained but cruel rulers and brave opponents, with the Archbishop of Canterbury on the improbable side of the angels.

Weinstein also tried her hand at various television sequels, *The Adventures of Sir Lancelot, The Buccaneers,* and *The Adventures of William Tell* ("The Robin Hood of the Alps"), some of these written by the same black-listed writers. *Sir Lancelot,* the most left-wing of the bunch—drawing upon the quiet, Cold War-era research of the Oxford University Marxist Group— did not work and lasted only a season or so. Still, Lardner estimated that between the Weinstein productions, he and Ian Hunter had, alone, written over a hundred episodes: an oeuvre of Robin Hoodish proportions.

American children of the day could be forgiven for merging *The Adventures of Robin Hood* with *The Cisco Kid* (1950–56), the most beloved children's program in 1955, the first adventure series shot in color, and most remarkably, the first series starring two Hispanic American actors. Its plot, based very loosely on O. Henry's *Heart of the West* (1907), was in turn based on a Texas gunman-gambler who in real life was by no means the warm-hearted savior of the poor. In the hands of filmmakers, however, Cisco became a substitute or extended Robin, with a dozen features mainly in the low-budget cowboy genre during the 1930s and '40s, climaxing (if that is the right word) with five starring Duncan Renaldo and Leo Carrillo through 156 episodes. Even more than generic Robin Hood, the *Cisco Kid* had already been played for laughs, among the best by Cesar Romero, Hollywood's real-life gayest blade, during the 1940s. The introduction of a sidekick opened up malapropisms, fat-man jokes, and so on, with hapless Pancho as the butt of jokes along with lawmen and criminals. *The Cisco Kid* could prove deeply offensive to Latino viewers (although it had large television audiences in Latin America during the 1960s), but it was saved from becoming a mere Zorro type because the latter (also based on short stories and introduced into silent films) had to be an aristocrat hiding his identity at night. Cisco, by contrast, remained a true desperado if falsely accused of various crimes, liable for arrest and perhaps lynching.

It would be difficult to find a television hero of the medium's early years more transgressive than Robin or Cisco, although the falsely accused hero staying one step ahead of the authorities has been a staple of the genre. In films, perhaps the *Son of Robin Hood* (1958) could be a contender for the title of transgressive, because the son is actually a daughter in men's clothes, played by June Laverick. Here, a certain barrier had been crossed.

Robin and the 7 Hoods (1964), starring Frank Sinatra, is more of a rip-off with icons of the real-life, mob-connected Rat Pack as the Merry Men:

Sammy Davis, Jr., might be considered the original "Saracen," although the film is set in Prohibition-era Chicago, not Sherwood Forest. Bing Crosby (minstrel figure) and Peter Falk (rival mobster) manage to be at least entertaining. More entertaining, at any rate, than the space cartoon TV version, *Rocket Robin Hood* (1966–69) with the story taking place in the year 3000. Or the first Robin Hood film gothic by Hammer Horror. Imagine Robin as a Norman and the horror becomes evident.

A 1969 pilot for a failed, low-budget television series released only in 1973, *Wolfshead: The Legend of Robin Hood* probably tried harder than any other to return to the original ballads as a model. It didn't get far as either film or television.

Robin and Imperial Crisis: Postmodern Robin

During the last quarter of the twentieth century with the "modern" itself passed into history, Robin of film and television Robin moved into the postmodernism as well. *Robin and Marian* has become the model against which all others can be reasonably judged, and after the 1950s television version, the most thoughtful Robin ever made modern. Director Richard Lester, working from a script by James Goldman, was ideal not only for his alliances with peaceniks (and the Beatles!) but also un-Hollywoodish choices from locale to characterization. It was frankly revisionist, beyond all previous Robin Hoods, in describing the Crusaders' slaughter of innocents (saving the rich for ransom, the strong for slavery, and murdering all the rest, slicing them up to seek out gold or silver they might have swallowed) after surrender. Even supposed Good King Richard, in charge of mass murder echoing the War Crimes across Europe thirty years or so earlier, is a creep.

Robin and Marian is also arguably Sean Connery's best (or at least most progressive) film and Audrey Hepburn's finest late performance. They share a geriatric romance, yet one more revisionist note. Hobbled by age and injury, former defenders of the forest join a disillusioned Robin back from the Crusades. Barely able to defend himself and recover Marian from her captivity, he willingly accepts at last the shared suicide that she has prepared and made inevitable. War brings many horrors, including a very real preview of the Holocaust, but no victors.

By the 1980s, Michael Praed and Jason Connery starred in the *Robin of Sherwood* TV series (ITV, 1984–86) in what some critics saw as a spiritual response to the viciousness and greed of Thatcherism destroying the decency and the social security of existing British society. Reinforcing Richard Lester's work, *Robin of Sherwood* is arguably the most influential treatment of the core Robin Hood legend after *The Adventures of Robin Hood*. Featuring the usual stories, a realistic period setting on locations in parts of England, and introducing the character of a Saracen comrade, the series died when the production company ran out of money.

Maid Marian and Her Merry Men (1989–93) a jolly, hugely popular but also socially critical children's television romp, showcases Robin as a hopeless but usually charming yuppie, reliant upon Marian to lead robberies and the defense of the poor. There are many silly songs, a good spirit of not taking grown ups' world too seriously, and even a Rastaman. In its own way and with special credit to star Kate Lonergan and the writers, the series continued the revisionist trend and still makes for good viewing.

By contrast, Kevin Costner's *Robin Hood: Prince of Thieves* (1991) is a romp without much in the way of politics or plot. At best, Costner is the seemingly abandoned son of one of the founder/defender/martyrs of the Magna Carta, carrying on the mission when he finally becomes aware of it. He, too, is war-weary, and instructed by his sidekick Muslim Other into a vague awareness of multiculturalism. But so much else is wrong here: the Old Ways—that is, witchcraft—are still much present, an evil threat to proper law, order, and certainly Christianity, and perhaps also to patriarchy since witches are the (female) carriers. A much-aged Sean Connery returns at the very end—as King Richard.

Robin Hood, the TV movie released in the same year and no doubt banking on the film's publicity, is actually somewhat better if by no means outstanding. A very young Uma Thurman as Maid Marian engages in battle, killing off a few baddies. Decades later, Disney's made-for-television movie *Princess of Thieves* has an adolescent doing the Robin thing, dully.

Robin Hood: Men in Tights (1994), essentially a satire of the Costner and Flynn films with an overlay of past Fairbanks's affect, is assembly-line Mel Brooks more than anything else. (Most the best minutes are now on YouTube.) Sight gags, satirical choral singing, sex jokes (erection and locked chastity belt) and Brooks himself as a rabbi mark ups, more downs, and a lot of dull stretches. The Hanna-Barbera *Young Robin Hood* (1991–92) with the whole gang as teenagers was created with the same bargain-basement animation as the rest of the studio's work, but the gags are no worse than those of Brooks.

Robin lampooned was old hat, anyway. Several MGM cartoons had long since made Robin into Bugs or Porky by the time a 1982 TV special had Rich Little playing all the parts in a Robin Hoodish hour. The Smurfs starred in their own *Adventures of Robin Smurf* the same year, and two years later, the talented George Segal, Morgan Fairchild, and Roddy McDowell played live in *The Zany Adventures of Robin Hood*, one more television experiment rapidly forgotten. From at least 1986, Robin has been featured in one adventure video game after another.

A hilariously dreadful *New Adventures of Robin Hood*, made for TNT and shot in Lithuania, screened in 1997–98, looked most like the campy and subversively lesbian *Xena: Warrior Princess*, but without the latter's humor. This was followed in 2009 with SyFy channel's *Beyond Sherwood Forest*, a

hokey, low-production version for kids in which Robin fights mythological creatures.

The latest British *Robin Hood* series (2006–09) strove for realism on a small budget, with minimalist sets and seemingly little rehearsal. The ruling class here is meaner, the masses suffer more evidently and painfully than in earlier series, and the cultural shifts of the decades register: the series features a black warrior priest and three tough, original female characters including a village working-class dame and a Saracen. Marian herself is brutally murdered, and by the last season, Robin can die so that "the legend" may continue on—but not for long, as the cancellation almost immediately followed.

In all this, the Moorish/Muslim/Rasta element increasingly necessary to the Robin Hood narrative seems to have been designed on the model of the perky, thoughtful (but also sexually appealing) Marian character. Thus, the casting: Nasir in *Robin of Sherwood*, Azeem (Morgan Freeman) in *Robin Hood, Prince of Thieves*, Asneeze (Isaac Hayes) and Achoo (Dave Chappelle) in *Robin Hood: Men in Tights*, and Djaq (the first female in this role) in the 2006–09 UK series, not to mention Barrington (Danny John-Jules) as the rapping quasi-Rasta in *Maid Marian and Her Merry Men*.

Ridley Scott's mega-million-dollar *Robin Hood*, scripted by Brian Helgeland is only the latest Robin Hood screen vehicle and not likely to last long in popular culture lore. Saracens are missing here, and anything important about the Greenwood saved until an egalitarian Hollywood Ending. Not quite a terrible film, it manages to get Robin defending the English peasantry as a common man that he is might properly do, even one back from the wars. He pretends nobility so as to step into the shoes of the dead Robin of Loxley. Admittedly, he does so perhaps expecting to be rewarded by entry into the nobility: aiding the masses is part of personal upward mobility, as most any successful Democratic politician knows. In the process, he successfully fends off the Norman occupiers, and wins over the late Robin's widow (Cate Blanchett). The action scenes meanwhile feature vast armed battles well known to fans of earlier Scott films. All in all, Robin has simply been plugged into a Hollywood scene; some might call him framed.

Comic Book Robin

The 1940s and '50s also happened to be the golden age of the comic book, ending with political attacks on comics during the McCarthy Era, the collapse of most comics publishers, and the beginning of the slow and incomplete recovery process around superheroes. A natural kids' hero, Robin nevertheless his early comic-format life in newspaper strips, and in a place where comic books somewhat lagged: Anglophone Canada.

In 1935, *Toronto Telegram* began a five-year-long original series drawn by Charles Snelgrove that was apparently picked up in some European papers.

Six years later, with U.S. entry into world war on the way, Robin had his own Canadian comic book, reprinted from the newspaper edition but colorized, and with new adventures added later. Wartime rules kept U.S. comics from entering Canada; in 1946, when the rules changed, the small Canadian comic book industry collapsed and with it, the Canadian Robin Hood. Meanwhile, Robin the character turned up in a DC "New Adventures" series during 1938 and disappeared after a half-dozen issues or so.

The most important and most enduring of Robin Hood comics belongs to Classics Illustrated. Published by Albert Kanter's Gilberton Company in December 1942, seventh in the original Classics series, it was also released (i.e., given away) by Saks in Manhattan for Christmas, afterwards went on sale, and (like the most popular Classics books) continued in print for decades after. Enthusiastic art by Louis Zansky, easily among the most notable Robin artists after Howard Pyle, set off the rather wordy text adaptation by Evelyn Goodman. It was all adventure—with no Maid Marian, among other missing elements. Victor Prezio, whose cover for a new 1957 Classics *Robin Hood* popularized the Robin icon with bow in hand, was conceptually closest to Pyle (with Marian finally part of the scene). This comic book's interior art was done by the Canadian-born Jack Sparling.

Meanwhile, British Thriller Comics, 1951–63, had Robin in many of its several hundred editions. Arguably, Robin Hood bucked the tide of the receding industry, fighting to stay alive. Richard Greene had acquired so much of a cult following that "Robin Hood Shoes" offered giveaway comics about their namesake, made available in selected shoe stores. Dell published one Robin Hood comic in 1960 as the television series faded into residuals. Marvel issued its own line of Classics in the 1970s with Robin in the seventh issue. DC, struggling for an audience, paired Robin with Wonder Woman among other innovations, creating the longest Robin Hood run in comics to that point. Gold Key comics did tie-ins with the Disney animated film in 1974 and another series appeared simultaneous with the Kevin Costner film.

Green Arrow, a bit of a knockoff Robin, was a bigger hit, created by one of the comic industry's giants, Mort Weisinger; it first appeared in 1941 as part of the Justice League. Notably dressed in green, an expert archer who creates assorted trick arrows (including a kryptonite arrow!), he seems otherwise more like Batman, an aristocrat who comes out (in every sense possible, during those days) to right wrongs, none of them environmental. In later decades, this Green Arrow became the voice for left-leaning, sometimes downright anticapitalist as well as antiracist and antiwar sentiments. Writer Denny O'Neil made him the hero of the disadvantaged, then paired him in 1970 with another green hero, the Green Lantern, in a remarkably socially conscious series. Killed off, then revived as a morally ambiguous figure, he continues to this day as a gritty character, an urban Robin not so different, perhaps, from the Robin of songs and chapbooks centuries earlier.

At this late date, but amid the rapid growth of the graphic novel, comes *Outlaw: the Legend of Robin Hood*, evidently intended for middle school students. Robin turns out to be a hereditary Lord, off to the Holy Land to beat back the "infidel Muslims," and comes back from the Crusades to save his people and their land (but not especially, or ecologically, the Greenwood). It is not a wholesale disappointment, but enough of a disappointment to be pretty toothless and a little too close to the West's current invasion, occupation, and devastation of Islamic societies afar.

REFERENCES

J.C. Holt, *Robin Hood* (London: Thames and Hudson, 1980).

William B. Jones, Jr., "Introduction," *Classics Illustrated No. 7, Robin Hood.* (Toronto: Jack Lake Productions, Inc., 2009), reprint of the *Classic Comics* edition.

Maurice Keen, *The Outlaws of Medieval Legend* (London: Routledge & Kegan Paul, 1961).

Stephen Knight, ed. *Robin Hood: An Anthology of Scholarship and Criticism* (Cambridge: D.S. Brewer, 1999).

Thomas H. Ohlgren, *Robin Hood: The Early Poems, 1465–1550, Texts, Contexts, and Ideology* (Newark: University of Delaware Press, 2007).

Lois Potter and Joshua Calhoun, eds., *Images of Robin Hood: Medieval to Modern* (Newark: University of Delaware Press, 2008).

David Wiles, *The Early Plays of Robin Hood* (Cambridge: D.S. Brewer, 1981).

Green Robin/Spirit Robin

"They say he is already in the Forrest of Arden, and a many merry men with him; and there they live like the old Robin Hood of England: they say many young Gentlemen flocked to him every day, and fleet the time carelessly as they did in the golden world."
—*As You Like It* (1600), Shakespeare on the exiled Duke

Green Robin, ecological Robin, has never been absent from the popular lore around the rebel. But our awareness of his value has grown over the centuries.

Henry David Thoreau, one of the key thinkers of the 1830s and '40s Transcendentalism, the American Renaissance, wrote that "English literature from the days of the minstrels to the Lake Poets—Chaucer and Spenser and Milton, and even Shakespeare included, breathes no quite fresh and in this sense wild strain." The "tame and civilized literature reflecting Greece and Rome" did not and could not encompass the "wildness" of the green-wood, and its wild man, Robin, who stood in for Nature itself. Hence, English chronicles "inform us when her wild animals, but not when the wild man in her, became extinct."

Thoreau may have been wrong on two points. First, that not all English literature was so confined, and second, that Robin was (or could be) truly extinct.

Still, the Sage of Walden Pond was on to something. There are assuredly Robin Hoods, wild men aplenty in legend and lore, also occasionally in real life. Their problem is that no "natural order" exists to be restored (and perhaps never did, but the illusion had vastly more reality in the medieval world), and their quest most often drives their modern counterparts beyond outlawry or social banditry into existential doubt and self-destructive nihilism. This is as true for nonwhite, fictional Bad Men of the Caribbean and Latin America as for the Bad Men of American westerns in pulp novel, radio, film, and television (and now in video games). What they have continued to share with old Robin, despite all the differences, is that they are on the run, surrounded in some cases by loyal (occasionally disloyal) lieutenants, more often by a woman, whether femme fatale or lost angel, who is destined to go down with them.

And yet they are not mere nihilists, these modern Robins manqué, let alone the agents of the bankers or sheriffs or the colonial office/Bureau of Indian Affairs. They voice a sentiment of freedom inspired by their readers and viewers, more desperate than they know themselves for some measure of emancipation, if only from the tedium of ordinary wage labor but more usually from worse deprivation, material and psychological, in a class society where true compassion is a rare quantity.

Green Robin was there from the start, although his full reappearance awaited the environmental recognition of earth's inhabitants at peril. By the fifteenth century and especially in the immediate aftermath, Robin became a veritable personification of summer through the practices of the Games. Some villages began the Games in April, some waited until July, but most settled around Mayday or the June Solstice.

So often, and not only in England, these games had pre-Christian origins, Roman or earlier. Burning wheels rolling down hills, mock royalty and similar may be associated with Fortuna, Roman goddess of fate; the "liminal" status of the sun on the verge of decline spoke to the fragility of life as the seasons pass and the life of the individual or family will pass with it. The syncretism of British (but especially Celtic-English, Scottish, Welsh, and Irish) Christianity, mixing old slogans and icons from previous centuries with new ones brought by Christianity, kept a "nature religion" alive through adaptation. Wise Christian authorities, especially in distant regions where Celtic traces remained strongest, judiciously accepted a host of popular holidays and habits, from fertility rituals to old gods merely renamed as new Jehovah.

And then there is the forest itself. Across all northern Europe, the forest was the center of the fairy tale, a place where anything can be found, dangerous, or marvelous—witches, dragons, and little people among the more obvious possibilities. The Norman yoke, establishing the deer as forbidden to kill, added another layer of mystery, making the forest a more secret or at least more dangerous place to visit. An early silent film had Robin and his followers magically assuming animal shapes true to each character.

A long-familiar controversy surrounds Robin's possible association with that English perennial mystery figure, the Green Man. Pageant characters dressed in outfits made of leaves logically found their way to tavern signs, and The Green Man became a lasting favorite pub name. Curiously, when the Reformation authorities sought to banish the Green Man, such figures on the signs were often replaced with Robin Hood (mirroring the replacement of Robin's May games, in some villages a bit later, with the Morris Dance).

Some twentieth-century folklorists have merged the Green Man, Robin Hood, the May King and others into one figure of wildness seen across large parts of Europe. Others have disagreed, citing assorted complexities and contradictions. Most recent studies of church art in England seem to recuperate the basic conclusion that the Green Man and "diffused foliate heads"

in church carvings have similar origins and may indeed be Robin by another name.

Meanwhile, the medieval cult of Robin Hood, in Scotland as well as England has accompanied Robin with twelve companions (i.e., twelve disciples), doing special dances, wearing fairy green. His ceremonies, overthrowing organized religion for a day, also reflect a variant tale of a royal Robin whose cousin, the prioress, stabs him so that he bleeds to death—reaffirming simultaneously his status as a martyr for the people, the yeoman's saint, and the dying and resurrected king of *The Golden Bough*.

Then again, Robin is also the pagan god Merddin in assorted mythology, all in green and the goddess' lover, symbolizing the virility of life before its waning, the approaching death and inevitable rebirth of vegetation, echoed in Robin's battles against the forces of night. In one favorite folkloric episode, evil Guy of Gisbourne is indeed clad in horsehide that Robin dons after killing his foe. Wearing the same horsehide to disguise himself and rescue Little John, Robin takes on the role of the Winter King, thus making him a god for all seasons. This Robin, at least, is also Merlin the Magician (as I am named fully: Paul Merlyn Buhle.)

In forested and formerly forested England, thousand of plants, hills and trees still carry Robin's name today, and assorted quaint adages of a roundabout logic offer wisdom contrary to merchant calculation and utilitarianism. In Welsh myths, he is identified with robin red breast (i.e., Spring) rivaling raven (i.e., Winter), and the victory of the Oak King over the Holly King (until later in the year when the Yule log itself will be burned). According to Robert Graves's account, "Hood" is Hod or Hud, which is to say log, said to be cut from the sacred oak and containing Robin himself! When burned at Christmas, it expels the wood louse known as Robin's Steed, and Robin's spirit escapes up the chimney. Suddenly a bird, he chases a rival, disguised also as a bird, and catches and kills him. Only at this time of year, Christmas or Boxing Day, is the wren pursued by real-life young men, something that is at all other times considered bad luck.

During "Hunting the Wren," town's boys kill and fasten a real wren to the top of a pole, carrying it from house to house, chanting and asking for money, finally burying it in the churchyard with honors. The lads then leave the churchyard, form a circle and dance to music. The killing of the wren, the Holly King, is to make possible the return of the Oak King, and the rise of Robin with his men who will catch and kill the Sheriff of Nottingham once again.

Months later, the season turns. Bonfires on hilltops and the community revelry led to the pairing of young villagers the night before Mayday, with the couples supposedly going off to pick hawthorne flowers and welcome dawn, but obviously up to other things as well. Children born of these "Greenwood marriages" were considered blessed as "merrybegots," whether the parents'

relations ever became formalized or not. At some of these village May pseudo-wedding ceremonies, a Friar Tuck-like figure, not an official minister, prevailed for centuries. Robin or his companions always, in one sense or another, remained on hand when joyous mischief took place.

In the larger logic of village survival, May was the time to herd the livestock out toward pastures high and low. One of the survivals into living memory, mainly in Ireland, has been the May Bush, decorated with flowers, ribbons, and (most significantly) colored eggshells. Robin, extended by yet another means into folklore, remained once again part of some fertility and earth-renewal narrative.

Here we need to stop and ask, where is Marian in the plot, and how does her action so often precipitate the conclusion to the narratives of Robin Hood? If, as Graves suggested, Robin Hood became a substitute religion by the sixteenth century, she would have been the Virgin Mary, Robin's devotional object, in response to the Protestant Reformation.

The story of the Crusades and their relationship to Robin Hood grows more complicated yet. Graves insists that some crusaders found themselves unexpectedly drawn to the heretical Christian sects protected by the Moslems. These sects worshipped Marian, a sort of love and fertility goddess descended from antiquity. In some later Robin Hood tales, she is seen as swarthy-faced and in *Book of the Saints* is thought to have traveled to the Holy Land from ancient Britain, becoming a prostitute who serves travelers (later risen to Heaven, she continues to indulge carnal sins). Alternatively Mary Gipsy, St. Mary of Egypt, with blue robe and pearl necklace, she is also the mermaid who blesses poets and lovers; Maid Marian (a variant of "Merry May") would naturally be Robin's Queen for real-life medieval Mayday revelry.

She is, at any rate, sexually alluring to Robin and he to her; in the conclusion of some versions, this attraction is consummated. In mostly recent feminist versions, Marian herself narrates the story, telling Robin's Men what they must do, then turning to tell us, the audience, long after the events took place what really happened. Her importance is likely to continue growing.

In the mostly grim episode of retelling with Marian at the center of at least some recent versions, she emerges into the woodland camp bringing news that the Sheriff is bent upon collective punishment in the usual fashion, with official pronouncements about Hearts and Minds disguising the real motives of control and exploitation. As she narrates, village huts have been burned and commoners tortured for information. None will inform on Robin, not even those most rebellious men and women who, as punishment, have their tongues cut out. None more give evidence, even when the announcement is made of public hangings to come.

In the conclusion of this narrative, Robin and a tactical group (disguised as monks come to watch the hanging) enter the heavily guarded village and

take up positions with their bows and arrows neatly tucked away. Little John and Friar Tuck lead another group hidden in the woods awaiting Marian's signal. The procession to the gallows commences and tears flood the faces of women and children as innocent boys are lead toward their demise. As the boys drop toward their death, four arrows masterfully whip past the ears of onlookers as the ropes are severed and the boys hit the ground hard but unscathed.

Robin and Will reveal their identities, and Little John and Friar Tuck lead their offensive from the woods. Villagers take up arms against the guards and the battle ensues full scale. This is class war. The Merry Men are, however, overpowered by force of arms, and their defeat in open battle becomes proof that they and their successors must prepare themselves for a long, perhaps centuries-long, guerilla conflict. In this moment, Marian demonstrates her courage and removes herself from the ruling group forever. According to C.L.R. James, modern literature is "modern" precisely because Fate is not determined in advance; the protagonist must *choose*, and Marian made her choice: she will live or die with the Resistance.

She assists a badly wounded Robin and leads his decimated followers back into the sheltering forest. In this retreat, a legend is confirmed. She did not join the physical battle here, either, but was key to the effort in every other way, intellectually and emotionally. Sometimes, however, she also proved herself equal or nearly equal to the physical capacities of Robin, her putative lover.

Thus, a seventeenth-century ballad, written by one otherwise unknown "S.S." and lost until Ritson's 1795 work, reads in part:

> A bonny fine maid of a noble degree,
> With a hey down down a down down Maid Marian calld by name,
> Did live in the North, of excellent worth,
> For she was a gallant dame.

> 2 For favour and face, and beauty most rare,
> Queen Hellen shee did excell;
> For Marian then was praisd of all men
> That did in the country dwell ...

> 4 The Earl of Huntington, nobly born,
> That came of noble blood,
> To Marian went, with a good intent,
> By the name of Robin Hood.

> 5 With kisses sweet their red lips meet,
> For shee and the earl did agree;
> In every place, they kindly imbrace,
> With love and sweet unity.

6 But fortune bearing these lovers a spight,
 That soon they were forced to part,
 To the merry green wood then went Robin Hood,
 With a sad and sorrowfull heart.

7 And Marian, poor soul, was troubled in mind,
 For the absence of her friend;
 With finger in eye, shee often did cry,
 And his person did much comend.

8 Perplexed and vexed, and troubled in mind,
 Shee drest her self like a page,
 And ranged the wood to find Robin Hood,
 The bravest of men in that age.

9 With quiver and bow, sword, buckler and all,
 Thus armed was Marian most bold,
 Still wandering about to find Robin out,
 Whose person was better then gold.

10 But Robin Hood, hee himself had disguised,
 And Marian was strangly attir'd,
 That they provd foes, and so fell to blowes,
 Whose vallour bold Robin admir'd,

11 They drew out their swords, and to cutting they
 went, At least an hour or more,
 That the blood ran apace from bold Robins face,
 And Marian was wounded sore.

12 'O hold thy hand, hold thy hand,' said Robin
 Hood, 'And thou shalt be one of my string,
 To range in the wood with bold Robin Hood,
 To hear the sweet nightingall sing.'

13 When Marian did hear the voice of her love,
 Her self shee did quickly discover,
 And with kisses sweet she did him greet,
 Like to a most loyall lover.

14 When bold Robin Hood his Marian did see,
 Good lord, what clipping was there!
 With kind imbraces, and jobbing of faces,
 Providing of gallant cheer . . .

17 Great flaggons of wine were set on the board,
 And merrily they drunk round

> Their boules of sack, to strengthen the back,
> Whilst their knees did touch the ground.

18 First Robin Hood began a health
 To Marian his onely dear,
 And his yeomen all, both comely and tall,
 Did quickly bring up the rear.

19 For in a brave veine they tost off the[ir] bouls,
 Whilst thus they did remain,
 And every cup, as they drunk up,
 They filled with speed again.

20 At last they ended their merryment,
 And went to walk in the wood,
 Where Little John and Maid Marian
 Attended on bold Robin Hood.

21 In sollid content together they livd,
 With all their yeomen gay;
 They livd by their hands, without any lands,
 And so they did many a day.

Warrior and lover alike, fully equal to her man in many respects in some early versions, Marian has managed to survive in Robin Hood lore. In literature, on stage, in comics and film, she has been, however, less active than Robin by far—and hardly erotic at all—until her revival under the influence of feminism. "Marian," variant on an ancient name for "the Lady" going all the way back to Sumer and Minoan Crete, has slowly been making a return.

Robin Hood and Euro-Mysticism

Sixteenth-century Central Europe would seem a long way from fourteenth-century England, but the Celtic culture behind historic Robin also reached from Ireland to modern Yugoslavia in the centuries before the Celts were themselves conquered and all but eradicated by the Roman Empire. The Celts—as least as described by their enemies, since they did not believe in writing of any kind, including their own history—were neither egalitarian nor peaceful. But they despised cities, and it is obvious that their artistic designs on various objects, reconfigured by William Morris and the Pre-Raphaelites, have served as tokens or models of Green. The Celts themselves doubtless borrowed from earlier cultures and perhaps (judging from artifacts) from ancient peoples of modern British/Irish lineage.

In the larger radical sensibility recurring intermittently from the birth of class society—with its cities and armies and oppressive state religions—onward, the Golden Day of the distant past has been held aloft as a Garden of

Eden time. There were no "gentlemen" served by slaves of any kind, whatever the other conditions of life may have been. The Radical Reformation, challenging Rome, had been prefigured for centuries (in *Piers Plowman* and by the Lollards, of course) before the violent uprisings were drowned in blood in a repression that united crown, army, and Protestant and Catholic authority alike in the same gory project.

The wake of the conflict and the ongoing battles among various Christian factions (not to mention Jews, whose mystery doctrines offered cosmologies for the taking, or borrowing) prompted new doctrines, less about political revolution than about spiritual revolution. The birth of romanticism can be found here, and nowhere better than in the ideas of the Görlitz shoemaker Jakob Boehme (1580?–1625), and the paintings of his near-counterpart, Hieronymus Bosch (1453?–1516).

Bosch, misunderstood for centuries in a Christian-based society, is the easiest to grasp for our subject. By abandoning sacred-looking images for something resembling comic art characters, he invented a sort of comics. Bosch also set his hermetic art to the purpose of examining class society's trajectory downward from an early innocence (where animals and humans communicate, people are innocently naked, and a blessed Greenwood sense prevails) to the subsequent rise of kings, armies, priests, and wars. The last panels of "The Garden of Delights," his greatest surviving work, are no garden of delight: innocents are eaten by monsters, and the process of defecation is one of gold coins coming out of a rear end, that is, gold as the real excrement.

The descendent of an artistic family emigrating from France to a small industrial town in Belgium, Bosch lived quietly, devoted to a perfectionist religious circle. His spiritual mentor, a wandering Italian Jew, had converted to Christianity and, later, repudiated the conversion. This mystery figure perhaps gave forth the mysteries of the Kabbalah—providing one interpretation of Bosch's own mysticism and look back at a lost paradise of decency and absence of class society.

Boehme is more difficult to grasp and remains so despite hundreds of volumes about him, and despite small armies of devotees from Czarist Russia to France and Britain. Hegel, in his history of philosophy, proclaimed Boehme the founder of German philosophy, as others called him the father or forerunner of German Romanticism, making him a grandfather to Hegel and to Marx, among so many others.

What did he believe and write down that prompted English churches of the eighteenth century, arguably including the church of William Blake's faith, to find in him the answers unavailable elsewhere? Where, for our purposes, can be found the link to William Morris, and thence backward to Robin Hood?

Here we turn to Central Europe. The philosophical kernel of recovering ancient rights was also one of recovering something lost in history.

Jakob Boehme, the common shoemaker, developed a philosophical vision as a repudiation of "historical faith," the attempt to grasp the objects of faith as historical events. History's development, overwhelmingly the emergence and consolidation of class society, was not the divine process at work, contrary to the court philosophers of those in power. Far from it. Boehme says:

"Now you ask: Since God is everywhere, and himself everything, how does it happen then that in this world there is cold and heat; and also that all creatures bite and strike each other, and there is nothing but pure grimness . . . ?"

Boehme added elements of a solution. Among them: "animals are not simply formed out of clay, for they have a spirit in them that is not reducible to mere earth and water . . . the 'circle of life' is everywhere, complete in each creature and latent in each element." Boehme envisioned, in some future golden age, that the Tree of Life, freed from the Merchant's grasp, would belong to all again. Boehme thus foresaw the Age of the Lily, forever associated with peace and harmony, would follow the chaos of pain and bloodshed in his own era. In the time coming, the human race was to be restored to wholeness and awareness, with mystic recognition of the coherence in all things, of all things, an awareness of the divine "ungrund" of a limitless, hidden deity whose creation was also self-recognition in the process of completion. Boehme's theology, especially his success in preparing European romanticism as the rebel against the existing social order, brings Robin back to life as defender of the commons with the Tree of Life intact.

Robin wishes only to restore "the natural," but in doing so, raises the prospect of a wholeness denied in class society.

REFERENCES

R.B. Dobson and J. Taylor, *Rhymes of Robyn Hood: An Introduction to the English Outlaw* (Pittsburgh: University of Pittsburgh Press, 1976).

Robert Graves, *The White Goddess: A Historical Grammar of Poetic Myth* (New York: Noonday Press, 1966).

Maurice Keen, *The Outlaws of Medieval Legend* (London: Routledge & Kegan Paul, 1961).

Thomas H. Ohlgren, *Robin Hood: The Early Poems, 1465–1560, Texts, Contexts, and Ideology* (Newark: University of Delaware Press, 2007).

Cyril O'Reagan, *The Heterodox Hegel* (Albany: SUNY Press, 1994).

Lois Potter and Joshua Calhoun, eds., *Images of Robin Hood, Medieval to Modern* (Newark: University of Delaware Press, 2008).

David Wiles, *The Early Plays of Robin Hood* (Cambridge: D.S. Brewer, 1981).

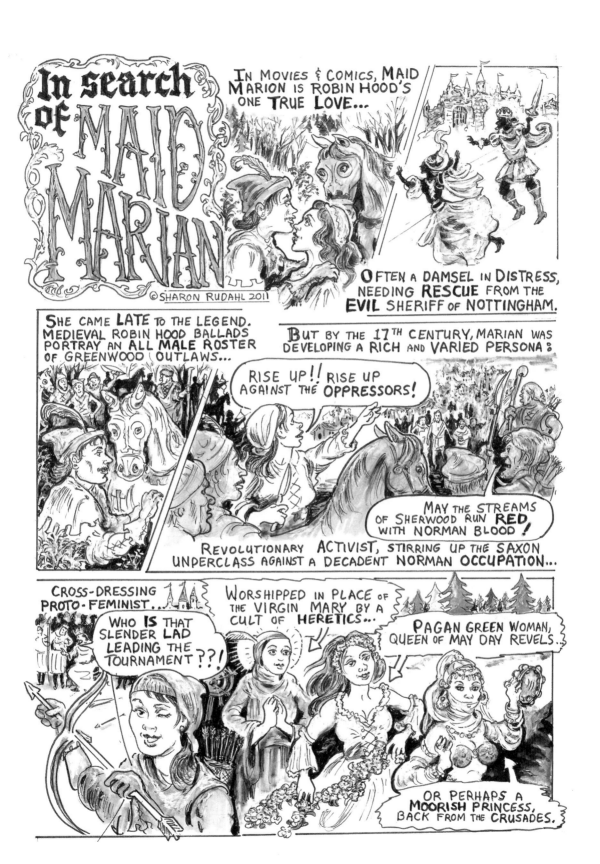

In Search of Maid Marian

IN MOVIES & COMICS, MAID MARION IS ROBIN HOOD'S ONE **TRUE LOVE**...

© SHARON RUDAHL 2011

OFTEN A DAMSEL IN **DISTRESS**, NEEDING **RESCUE** FROM THE **EVIL** SHERIFF OF **NOTTINGHAM.**

SHE CAME **LATE** TO THE LEGEND. MEDIEVAL ROBIN HOOD BALLADS PORTRAY AN **ALL MALE** ROSTER OF GREENWOOD OUTLAWS...

BUT BY THE 17TH CENTURY, MARIAN WAS DEVELOPING A **RICH** AND **VARIED** PERSONA:

RISE UP!! RISE UP AGAINST THE **OPPRESSORS!**

MAY THE STREAMS OF SHERWOOD RUN **RED** WITH NORMAN BLOOD!

REVOLUTIONARY **ACTIVIST**, STIRRING UP THE SAXON UNDERCLASS AGAINST A DECADENT NORMAN **OCCUPATION**...

CROSS-DRESSING PROTO-FEMINIST...

WHO **IS** THAT SLENDER **LAD** LEADING THE TOURNAMENT??!

WORSHIPPED IN PLACE OF THE VIRGIN MARY BY A CULT OF **HERETICS**...

PAGAN GREEN WOMAN, QUEEN OF MAY DAY REVELS...

OR PERHAPS A **MOORISH** PRINCESS, BACK FROM THE CRUSADES.

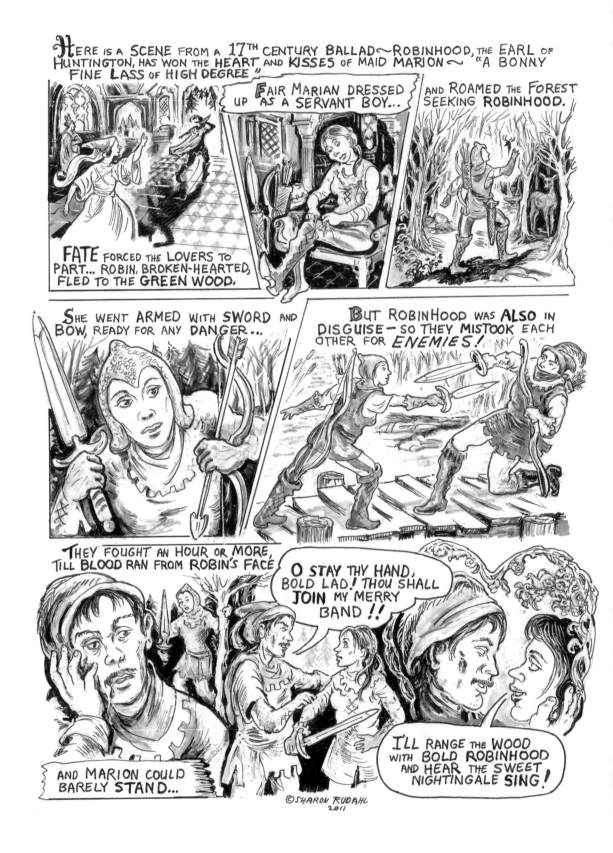

Conclusion: Robin of Global Fear, Robin of Global Hope

"Man has an insatiable longing for justice. In his soul he rebels against a social order which denies it to him and whatever the world he lives in, he accuses either that social order or the entire material universe of injustice... And in addition he carries within himself the wish to have what he cannot have — if only in the form of a fairy tale."

—Eric Hobsbawm, *Bandits* (1981)

Robin and the Commons

We begin to conclude our story with Robin Hood as defender of the Commons, an idea with a large Robinesque trajectory.

A recent special issue of the journal *An Architektur*, published in Germany by what used to be called the Red/Green Left, captures the idea best for today. The struggle for common space, common decision-making, whether rural, metropolitan or global, can be usefully traced back, in one part of the world, to the changes forced upon royalty in the Magna Carta. They can carry us forward to our opposition against privatization of formerly public goods and space, beyond remedies for the excesses of contemporary capitalism, toward a society of a different (and more sustainable) kind. Many millions of farms, urban neighborhoods, and software programs can be or in many cases are already being operated on some basis of sharing. The editors of *An Architektur* dub this process of struggle for position "commoning."

Thus "commoning" is the opposite of the imperial mode, right down to the struggle against dams being constructed on rivers in or outside forests, around the world. If the "primitive accumulation" (Marx's own phrase) of capitalism was effected through enclosures—the privatization of previously common lands for the purpose of successful wool production a couple of centuries after Robin's appearance—then he and the Merry Men (not forgetting Maid Marian) had been seeking to nip the process in the bud. Marx erred, writing in the middle of the nineteenth century, not by failing to see the utter misery introduced to move primitive accumulation forward, but by not seeing that primitive accumulation as a permanent process. With so little of the planet not yet completely exploited, the process nevertheless accelerates. We need Robin more than ever.

We need Robin because rebellion against deteriorating conditions is inevitable; without clear-headed Robins, however, without hundreds of thousands or millions of them seeing clearly, the impulse to rebel will surely be lost in internecine struggle and crime, organized and unorganized, the mirror of class society at its destructive extreme. We need them more now than ever before and in this writer's view, they also need Robin. No existing political model, Marxist, Social Democratic, Leninist, anarchist, or other is suitable for what lies ahead.

Dark Robin

In the middle of the nineteenth century, Marxists competed with popular, revolutionary-minded literary utopians, some of whose best were more likely to write about dystopia than utopia and for good reason. Perhaps this was especially true in the United States, where the democratic heritage was assumed and the ongoing loss of it to emerging political, business, and other powers seemed to mark a near-hopeless devolution, as early as the 1840s. Indeed, the appearance of the penny weeklies, the first television-like sources of fiction for the masses, brought this sentiment to the fore—and also the master-author of the genre, George Lippard.

Lippard, a Ricardian socialist who churned out dozens of novels before his death at thirty-four, saw himself surrounded by a world of capitalist corruption including wage and sexual exploitation, disguised by deceptive rhetoric about American greatness and democracy for all. His heroes, desperately brave but haunted by a sense of impending tragedy, see things close at hand, and know better. Some head for Manhattan, where the swift development of wealth and corruption has created an underground world of capitalistic decadence only blocks from a starveling population of the poor; some head West toward the frontier, where they find conditions as bad as at home. Still others throw themselves at the oppressors with individual acts of revenge and redemption. They continue to dream of a world of brotherhood, but can only imagine a secret global society working toward that end. Exposure would mean total repression. In the last years of his young life, Lippard formed a secret labor organization foreshadowing the Knights of Labor.

Lippard knew the sources of his suffering from personal experience as a rural refugee to Philadelphia, with a sister who turned from factory work to prostitution. His pen-swift successors in the pulps of the 1850s–80s were merely writers of westerns or assorted other adventure-narratives (pirates constituted another favorite), professional hacks with little if any social sensibility. The main and most successful Robin Hood types of the Yellow Backs drank heavy liquor, shot dead every enemy they chose and defended a new law and order that rarely included nonwhites—and with the rarest exceptions, only punished land-stealers who stole from or did ill to *other* whites. The exotic lady pirate, the lady outlaw not very close to Maid Marian,

had already been introduced by Lippard as a Queen of Sin, and added little except extra melodrama.

Still, even the Jesse James types, based upon former Confederate soldiers who came West with a taste for violence, were bound to end in tragedy mirroring something larger. This tragedy, rendered into an existential metaphor or commentary about the apparent freedoms of Americans to be violent—and the Boot Hill consequences—proved more vital than the immediate subject. As time went on, these pseudo-Robin Hood creations increasingly seemed to help out poor settler families besieged by the bankers who ran the town (and owned the sheriff), and by lawyers, their swindling agents. They spent their days on the run, generally deprived of any Sherwood Forest safe-zone. The enemy, *their* enemy, was everywhere, ready to betray them into some final shoot-out.

The great Populist orator-author Ignatius Donnelly thus wrote the hugely popular novel *Caesar's Column*, and best-selling socialists following him, Robert Allen England (*Darkness and Dawn*) and Jack London (*The Iron Heel*), added their own early twentieth-century versions, all of them sketching a dark future, with protagonists lost in a world all but destroyed by war, and still ridden with authoritarian, military-style abuses. They and their readers foresaw the twentieth century of increasing brutalization of civilians in any conflict, and of Robin types on the run.

Silent films promoted the "masked man" along with the usual heroes, and added something new to the aura of the outsider who brings justice. That masked man, always suspected of crime, convinces townsfolk of his innocence by the end of the adventure but gains nothing for himself except moral satisfaction. In each new adventure he (and usually a sidekick) start over, suspect as ever. Existential heroes, yet more desperate, were just waiting for their turn, so to speak, at the back of the film production sets.

During the late 1920s closing years of the silents, the hero gangsters took the screen, and have never since left. The Crash and the Depression brought an unprecedented bitterness against the social system, created a world of organized crime with new romantic doomed figures, and brought to Hollywood screenwriters with political views that would earlier have barred them from the real-life still nonunion, one-industry town operations run by Jewish (and Gentile) Republican moguls.

That rebels and outright Reds would soon be scriptwriting hits like *Little Caesar, The Public Enemy,* and even *She Done Him Wrong* (where the demimonde world of Mae West held tough, rebellious, and erotic women), made perfect sense. James Cagney in particular, as the tough but emotionally damaged criminal, explored Depression moods and the self-destructive, typically American individualism that characterized early responses to the social crisis. Prison breaks from murderous conditions, heroes on the run after being falsely accused of murder or other crimes and hard luck kids on the other side

of the law were all fairly typical plots of the time. Positive portrayals of labor unions, like dignified portrayals of nonwhites, were effectively banned from the screen, leaving writers, directors, and actors with a need for something else to move the plot. The criminal or accused criminal was always available.

That was only the beginning, of course. Wartime saw the onset of more artistic and psychologically deeper films with these kinds of protagonists. They may root out capitalists who are discovered to be collaborating with the Nazis, but they must die anyway from the hopelessness of their personal condition. The private dick manages not to die, but everyone else around him and dear to him in the film (or novel) may well be murdered by the end. Humphrey Bogart was perfect in *The Maltese Falcon*, and countless lesser heroic antiheroes found themselves in the same circumstances. More than a few stand vindicated in the public eye, most often by doing what the police themselves cannot or will not do. Mostly, they are fortunate to survive, and perhaps (at least in some films and stories) find a true and potentially long-term lover. Occasionally, they bring down conspiratorial creatures close to real life, like the publisher in novel and film *The Big Clock*, who resembles both William Randolph Hearst and Henry Luce. Mostly, and by contrast to Robin, they are so flawed that their journey must lead them toward spiritual, perhaps actual death: they cannot live in this corrupted world.

The rush of public disillusionment accompanying the psychological shock of the Holocaust, the Atomic explosions and the possibility of a near-time Third World War pushed this phenomenon forward. Even for the heartless, the prospect that all human life would suddenly be ended cast a gloom across sunny American optimism that mere consumerism could never quite lift. And what cinematic heroes follow! Not only Bogart, but Burt Lancaster, Kirk Douglas, Robert Mitchum, and perhaps above all, for art quality alone, John Garfield were perfect to undertake doomed quests, sometimes for only money, more often for love, and sometimes to rescue the underprivileged from the manipulating power of politicians, big businessmen, and other crooks.

Often enough, these cinematic pioneers of the road film are far beyond the cities, seeking an elusive free space in small town California, or the desert, or even the new towns where life might be different, at least for refugees from working-class daily life. Burt Lancaster in *The Crimson Pirate* offers the happy-ending, juvenile-enticing entertainment that the noir beleaguered figures cannot reach, perhaps because there is no geography outside the scope of ill fate. Least of all is there a community of thieves: here, the mob has taken control and its ruthlessness offers another path to self-destruction for those desperate enough to join up. Male heroes are so near depression at the happiest moments that destiny is certain to pull them down. Yet they somehow present themselves as the dream of escape, no matter how futile the dream. In them far more than the cheerful Disney version, Robin lives. They cannot bear life in a *Dragnet* world where law and order keep the current regime in power.

Horror and science-fiction comic art of high artistic quality and good writing, published as "New Trend" EC Comics during the early 1950s, carried the same burden: desperate, flawed men and women on the run with only supernatural hope for the evil to be punished; and Sci-Fi futures of post-atomic war scenes with humanity struggling to recover something of its lost civilization.

If we look elsewhere in the Anglophone world for rebellious "Black Robins," among those populations certain to imbibe Robin Hood as rebel literature, we come readily to the Empire's peripheries, the readers in the Anglophone Caribbean. The Caribbean has been a special site for the rebel, first of all because failed slave revolts of early centuries of colonization faded back into the small-scale countryside and then lived on in song and the accompanying carnival music. The particulars of the Afro-Caribbean experience, including Marcus Garvey and Rastafarianism in the twentieth century (and beyond), have added an important mythic space—evident especially in carnival dress and dance—where almost anything might happen but where the dream of escape from "Captivity," in other words, from history as class and race history, somehow reign supreme. The escape is elusive, the fugitive most often unable to grasp the social significance of his own acts that finally become hardly more than criminal. Still, something large has been illuminated in the process.

At first glance, the historical situation of the Caribbean is entirely different from that of rural England: following the extermination of native populations, African slaves were introduced to the Caribbean, with no "natural" rights or any others. Teaching them how to read or write was a capital offense and no form of torture known to thirteenth-century England was unknown here—one could easily suggest that brutality at its most bloody, not in war but daily life, was transported rather than being abolished. English-imitation colonial culture, from dress fashion to play-going, was the creation of whites urgent to make fortunes and return home to English estates while avoiding the pollution of race-mixing. Rather than reflecting the rich culture around them, whites ignored and denigrated it.

Still, slaves dreamed of freedom and took every opportunity to seize that freedom physically, while holding out the mythic freedom of return to Africa, in death if not in life. They also drew on their culture (or cultures) and rituals to combine such intimate matters as fertility with a sense of being wronged by history but still enjoying in "carnival" a once-yearly pleasure and cultural recuperation. During carnival, historians and folklorists have discovered, artifacts of musical instruments brought from Africa were reborn, or something like them invented anew with the materials at hand. By the later nineteenth century and amid bitter disillusionment with the supposed joys of emancipation (former slave owners were repaid, former slaves definitely not), annual events brought watchful anxiety from whites. Trinidad's

famed Canboulay Riots of 1884 with drummers, dancers, singers, and pros-titutes among assorted revelers prompted colonial officials to bar entry into Port of Spain. The British governor cashiered the city council for refusing to enforce the ban, and the Calypsonians sang, "Jerningham the Governor/It's a rudeness into you/a fastness into you/To break up the laws of the borough council." They were reasserting traditional privileges or protections, few as those may have been.

The emergence of mass culture (including impulses from Harlem, music and printed image) and the arrival of mostly American and British films and television including *The Adventures of Robin Hood*, came simultaneously with the accelerated striving for Caribbean independence. Calypso and steel drum bands took the name of outlaws as well as of seemingly fantastic beings (like Houdini) of American film titles (*Casablanca*) and real-life "dread" figures (Black Stalin as the most outrageous of these). The all-time most popular Anglophone Caribbean film, *The Harder They Come* (1972) drew the fate of a rascal on the run who cannot escape his death in a scene that he imagines to be an American western shoot-out. Jimmy Cliff, singer and lead in the film, has represented themes of Rastafarianism and redemption of Caribbean men and women in his music before and after starring in the film.

The Anglophone or English-speaking Caribbean mass following of Marcus Garvey emerged first in the late 1910s and '20s, with Garvey the Jamaican an influential world figure in Harlem—until expelled from the United States and eventually returning back home to Jamaica. Political impulses on the Left that would have taken another course elsewhere (and did in Cuba, Haiti, and across the non-English-speaking Caribbean), joined Black consciousness to labor conflict in unpredictable mixtures but also with underlying themes of an almost otherworldly Pan-Africanism. Haile Selassie himself visited Jamaica in 1966, setting off cultural and political fireworks from the parliament to the displacement communities of rural peoples for development projects of Jamaica in the 1940s–60s. Driven into "shanty-town," these impoverished populations dreamed of a different society and chanted about it. Futile urban and countryside guerilla adventures unfolded.

Jimmy Cliff's musical self-image, a type of Robin Hood if not quite in the same words, would redeem the damaged ecology, uplift the "Black Queen" from her centuries-long descent and exploitation, and restore a natural rela-tion to human and environment: a solution of which Robin Hood would have thoroughly approved. Meanwhile, real-life Rasta colonies, when not exploited by drug dealers, set themselves up in low-tech corners of various islands like Antigua, seeking to create colonies with a different kind of freedom, a lan-guage based in nature rather than imperial terms, and aspirations for global redemption.

But it is also true that evocations of the wondrous natural setting, near-jungle of exotic birds and butterflies close at hand, figure into the music and

other expressive arts from painting to sculpture. Nature here is the ever-present "outside" that can be poisoned but finally cannot be conquered; it is an arena of freedom as well as of danger.

In the novels of former jungle-land surveyor and poet Wilson Harris, Robin Hood-like characters, driven to the backwoods, are likely to be rascals themselves, unable not to be rascals. They are controlled (if at all, and if so, only for a time) by powerful women, erstwhile whores who have taken power over their own lives. One of Harris's most revered works, *The Far Journal of Oudin* (from *The Guyana Quartet*) shows us the protagonist's friend, Ram, as described by Harris:

> Ram knew the motion of the river by heart . . . had always followed with his eye—seeing and yet blind to the light in the depth—the dark bed and journey of the water past the far-strung cracks and windows and settle-ments of the brooding land . . . and further still . . . into the sea.

Here, "survival was a miracle" and yet, as a people, the inhabitants mixed with every race and did survive. In Harris's generation, they learned English literature and, if fortunate, made their way to Mother England to become writers, never giving up the literature's traditions—or their own personal immersion in the Caribbean scene.

Postcolonial trends reaching into the new century, increasing impover-ishment, political disillusionment, political corruption and the "brain drain" to the United States, Canada, and the United Kingdom, brought forth a new and difficult Robin Hood, one evidently beyond redemption: the antisocial criminal. Jamaica, always a home of rebellions, suffered the worst, with whole sections of cities taken over by gangs, residents terrified but also corrupted by murderers and worse. These gangs, like the contemporary drug gangs of Mexico valorized by "narcocorridos," ballads of narco-capitalist adventures, sometimes falsely claimed the mantle of some Robin Hood variant if not Robin himself, while their deeds made them far more like U.S. corporate investors and State Department behavior, always bullying, ever indifferent to the growing ecocrisis of the region.

Our search for tomorrow's Robin takes us to carnival in Trinidad, where the steel drum was invented a generation after the Calypso tents in the early twentieth century. At carnival time, the tents have always provided a home for the transgressive. What could not be said politically in any other framework—by mere natives of the colony looking over their shoulders at colonial independence—could be explored in Calypso and in musical deriva-tives organized around Pan, Soca, and East Indian-related music. By the 1940s and '50s, with independence in the air and U.S. forces still continuing their military occupation dating to the War (turning over authority, more than symbolically, from British to Americans), the carnival themes turned radical in every sense. Their themes have frequently remained so in one sense

or another, through the assorted problems of islands scarce in resources and overwhelmed by neocolonialism.

One of the most familiar of the carnival tent "characters" during this century has been Midnight Robber. No mere thief (or sexual athlete), Robber continues quite explicitly the African role of storyteller. In the "mas" or masquerade, he is seen in many cases with his skull-encrusted black cape, wildly fringed and broad-brimmed hat, and eagerness to talk. In the tents, he becomes the master voice, recounting at once his own spectacular life (starting with the incredible wisdom and equally incredible deeds at an early age) as well as the story of slavery, capture, transportation, exploitation in the New World and the story of resistance. Midnight Robber makes a point of engaging the audience in dialogue about themselves.

In 2010, the Oilfields Workers Trades Union (OWTU), the most militant of Trinidad and Tobago's labor bodies, commissioned an American labor-radical muralist, Mike Alewitz, to give them a mural suitable for their headquarters. There, in a side room, space had been made a quarter century earlier for their own living idol, the octogenarian C.L.R. James, who as a Trinidadian native went off to Britain to become a cricket journalist, author of *The Black Jacobins*, Marxist theoretician, anticolonialist and, in his final decades, the last of the great Pan-African intellectuals.

The Midnight Robber (seen on the back cover of this book) is more than a little like Black Robin. In the days of the socialist Michael Manley administration in Jamaica, Dennis Barth alias "Copper" came into the public eye as a criminal in the tradition of the fabled Robin, stealing from the rich and giving to the poor. He was well loved in "shanty-town," as a generous representative of the neighborhood and culture. Copper escaped from prison in 1977 and remained at large, a mythic figure until killed by police in a hail of bullets. His lawyer, Antonette Haughton, Black Power supporter and one of the outstanding women's rights activists of the region, had significantly joined the circle of Bob Marley, who dubbed her "lawyer dawta." Marley's evocation of peace (with marijuana) and the countryside had thrilled fans around the world, and helped in its way to bring "Green" into the popular patois. The circle was completed in martyrdom soon enough, with Manley, Barth, and Marley all dead but not forgotten, even as neocolonial governments reclaimed control of the island's economy at large, and as drug dealers reinforced their power within urban sections of the island through the instrument of the historically pro-U.S., conservative Jamaica Labor Party (JLP).

Meanwhile, Wilson Harris's last great novel restaged the Jonestown tragedy, with Reverend Jonah Jones (stand-in for Jim Jones) determined to seek the neocolonial predator in its lair, poison its air, or kill it with anything else if necessary as revenge for the wrongs done for centuries. This is a madness with historical reason, Robin gone wrong after seven centuries of being denied except as harmless fantasy or pursued as a "terrorist."

Is this where Robin ends? We do not think so. When "the wilderness comes into its own as extrahuman territory which unsettles the hubris of a human-centered cosmos that has mired the globe since the Enlightenment," to quote Wilson Harris, then we learn to see differently, no longer looking at nature as a mere medium that we manipulate at will. This is the true message of the Greenwood and of Robin. We are the heirs to these long-ago rebels.

At the approaching real end of history—not the much-celebrated market triumph of the hubristic 1990s, but the extended moment of potential self-annihilation—we still have the opportunity to learn. "The stress on purely individual character was an impoverishment of tradition," Harris says. Now we must move beyond.

But as we move on, we are wise to look back as well. And as we look to the hard work ahead, we always see Robin as the master of playful imagination. So we might as well end with a famous passage of American literature by the greatest of all American writers, a notable socialist and dreaded (in some quarters) anti-imperialist who gave his last best efforts to ending the U.S. assault upon the Philippines. Here, cleverly disguising his extraordinarily radical vision from all those except readers of all ages who look closely, Twain offers to readers one of his all-time favorite characters, Tom Sawyer.

> *Just here the blast of a toy tin trumpet came faintly down the green aisles of the forest. Tom flung off his jacket and trousers, turned a suspender into a belt, raked away some brush behind the rotten log, disclosing a rude bow and arrow, a lath sword and a tin trumpet, and in a moment had seized these things and bounded away, barelegged, with fluttering shirt. He presently halted under a great elm, blew an answering blast, and then began to tiptoe and look warily out, this way and that. He said cautiously—to an imaginary company:*
>
> *"Hold, my merry men! Keep hid till I blow."*
>
> *Now appeared Joe Harper, as airily clad and elaborately armed as Tom. Tom called:*
>
> *"Hold! Who comes here into Sherwood Forest without my pass?"*
>
> *"Guy of Guisborne wants no man's pass. Who art thou that—that—"*
>
> *"Dares to hold such language," said Tom, prompting—for they talked "by the book," from memory.*
>
> *"Who art thou that dares to hold such language?"*
>
> *"I, indeed! I am Robin Hood, as thy caitiff carcass soon shall know."*
>
> *"Then art thou indeed that famous outlaw? Right gladly will I dispute with thee the passes of the merry wood. Have at thee!"*
>
> *They took their lath swords, dumped their other traps on the ground, struck a fencing attitude, foot to foot, and began a grave, careful combat, "two up and two down." Presently Tom said:*
>
> *"Now, if you've got the hang, go it lively!"*

So they "went it lively," panting and perspiring with the work. By and by Tom shouted:

"Fall! fall! Why don't you fall?"

"I sha'n't! Why don't you fall yourself? You're getting the worst of it."

"Why, that ain't anything. I can't fall; that ain't the way it is in the book. The book says, 'Then with one back-handed stroke he slew poor Guy of Guisborne.' You're to turn around and let me hit you in the back."

There was no getting around the authorities, so Joe turned, received the whack and fell.

"Now," said Joe, getting up, "you got to let me kill YOU. That's fair."

"Why, I can't do that, it ain't in the book."

"Well, it's blamed mean—that's all."

"Well, say, Joe, you can be Friar Tuck or Much the miller's son, and lam me with a quarter-staff; or I'll be the Sheriff of Nottingham and you be Robin Hood a little while and kill me."

This was satisfactory, and so these adventures were carried out. Then Tom became Robin Hood again, and was allowed by the treacherous nun to bleed his strength away through his neglected wound. And at last Joe, representing a whole tribe of weeping outlaws, dragged him sadly forth, gave his bow into his feeble hands, and Tom said, "Where this arrow falls, there bury poor Robin Hood under the greenwood tree." Then he shot the arrow and fell back and would have died, but he lit on a nettle and sprang up too gaily for a corpse.

The boys dressed themselves, hid their accoutrements, and went off grieving that there were no outlaws any more, and wondering what modern civilization could claim to have done to compensate for their loss. They said they would rather be outlaws a year in Sherwood Forest than President of the United States forever.

REFERENCES

An Architektur 23 (July 2010), Berlin.

Paul Buhle and Dave Wagner, *Radical Hollywood: The Untold Story Behind America's Favorite Movies* (New York: New Press, 2002).

Wilson Harris, *The Guyana Quartet* (London: Faber and Faber, 1985).

Wilson Harris, *Jonestown* (London: Faber and Faber, 1996).

Eric Hobsbawm, *Bandits* (New York: Pantheon, 1981).

Hollis "Chalkdust" Liverpool, *Rituals of Power & Rebellion: The Carnival Tradition in Trinidad & Tobago, 1763–1962* (Chicago: Research Associates School Times/ Frontline, 2001).

Mark Twain (Samuel Clemens), *The Adventures of Tom Sawyer* (London: Chatto and Windus, 1876).

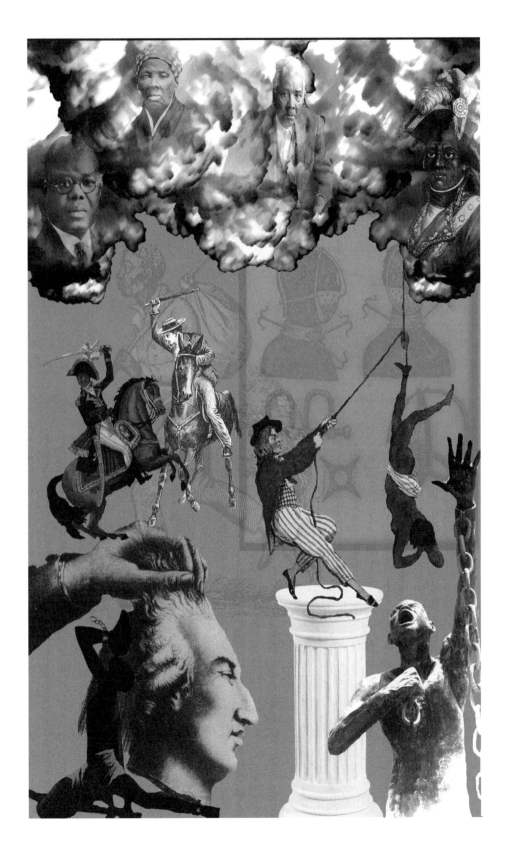

Therefore be ye bold, and again bold, and thrice bold! Grip the bow, handle the staff, draw the sword and set on in the name of
fellowship!

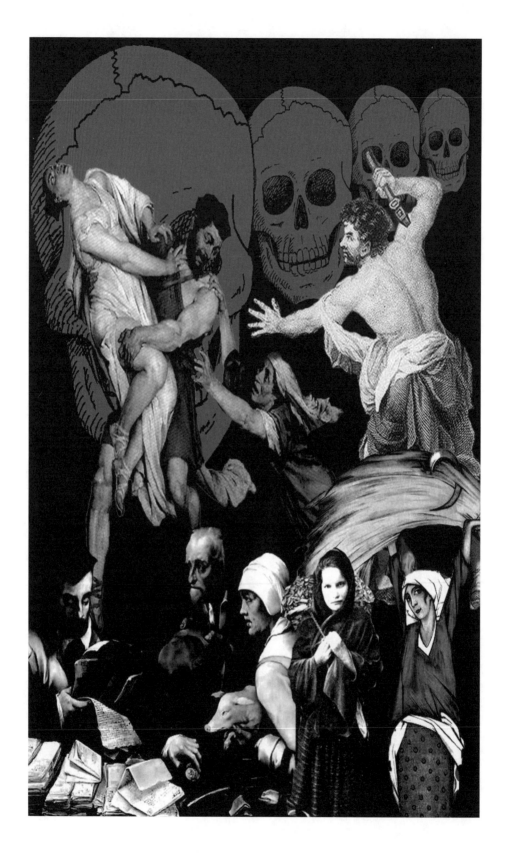

About the contributors

Paul Buhle, founder-editor of the new left journal *Radical America*, is now an ex-academic, editing radical comic art books from Wisconsin. He is the authorized biographer of C.L.R. James, and a scholar of the Hollywood Blacklist, comic art, labor, and the Left.

Gary Dumm, Cleveland native and prolific comic artist, has contributed to many anthologies, is the principal artist of *Students for a Democratic Society: a Graphic History* and has been published in the *New York Times*, *Entertainment Weekly*, and France's *Le Monde*, among other outlets.

Christopher Hutchinson, a young artist and Connecticut native, ran for Congress as a socialist in 2010.

Sharon Rudahl, erstwhile civil rights activist and artist for the antiwar movement, was a leading comix artist of the underground era. Her recent work includes *Dangerous Woman: The Graphic Biography of Emma Goldman* and contributions to many anthologies. She lives in Los Angeles.

ABOUT PM PRESS

PM Press was founded at the end of 2007 by a small collection of folks with decades of publishing, media, and organizing experience. PM Press co-conspirators have published and distributed hundreds of books, pamphlets, CDs, and DVDs. Members of PM have founded enduring book fairs, spearheaded victorious tenant organizing campaigns, and worked closely with bookstores, academic conferences, and even rock bands to deliver political and challenging ideas to all walks of life. We're old enough to know what we're doing and young enough to know what's at stake.

We seek to create radical and stimulating fiction and non-fiction books, pamphlets, t-shirts, visual and audio materials to entertain, educate and inspire you. We aim to distribute these through every available channel with every available technology — whether that means you are seeing anarchist classics at our bookfair stalls; reading our latest vegan cookbook at the café; downloading geeky fiction e-books; or digging new music and timely videos from our website.

PM Press is always on the lookout for talented and skilled volunteers, artists, activists and writers to work with. If you have a great idea for a project or can contribute in some way, please get in touch.

PM Press
PO Box 23912
Oakland, CA 94623
www.pmpress.org

FRIENDS OF PM PRESS

These are indisputably momentous times — the financial system is melting down globally and the Empire is stumbling. Now more than ever there is a vital need for radical ideas.

In the three years since its founding — and on a mere shoestring — PM Press has risen to the formidable challenge of publishing and distributing knowledge and entertainment for the struggles ahead. With over 100 releases to date, we have published an impressive and stimulating array of literature, art, music, politics, and culture. Using every available medium, we've succeeded in connecting those hungry for ideas and information to those putting them into practice.

Friends of PM allows you to directly help impact, amplify, and revitalize the discourse and actions of radical writers, filmmakers, and artists. It provides us with a stable foundation from which we can build upon our early successes and provides a much-needed subsidy for the materials that can't necessarily pay their own way. You can help make that happen — and receive every new title automatically delivered to your door once a month — by joining as a Friend of PM Press. And, we'll throw in a free T-shirt when you sign up.

Here are your options:

- **$25 a month** Get all books and pamphlets plus 50% discount on all webstore purchases

- **$25 a month** Get all CDs and DVDs plus 50% discount on all webstore purchases

- **$40 a month** Get all PM Press releases plus 50% discount on all webstore purchases

- **$100 a month Superstar** — Everything plus PM merchandise, free downloads, and 50% discount on all webstore purchases

For those who can't afford $25 or more a month, we're introducing Sustainer Rates at $15, $10 and $5. Sustainers get a free PM Press T-shirt and a 50% discount on all purchases from our website.

Your Visa or Mastercard will be billed once a month, until you tell us to stop. Or until our efforts succeed in bringing the revolution around. Or the financial meltdown of Capital makes plastic redundant. Whichever comes first.

William Morris: Romantic to Revolutionary

E.P. Thompson
with a foreword by Peter Linebaugh

ISBN: 978-1-60486-243-0
$32.95 880 pages

William Morris—the great 19th century craftsman, architect, designer, poet and writer—remains a monumental figure whose influence resonates powerfully today. As an intellectual (and author of the seminal utopian News From Nowhere), his concern with artistic and human values led him to cross what he called the 'river of fire' and become a committed socialist— committed not to some theoretical formula but to the day by day struggle of working women and men in Britain and to the evolution of his ideas about art, about work and about how life should be lived.

Many of his ideas accorded none too well with the reforming tendencies dominant in the Labour movement, nor with those of 'orthodox' Marxism, which has looked elsewhere for inspiration. Both sides have been inclined to venerate Morris rather than to pay attention to what he said.

Originally written less than a decade before his groundbreaking *The Making of the English Working Class*, E.P. Thompson brought to this biography his now trademark historical mastery, passion, wit, and essential sympathy. It remains unsurpassed as the definitive work on this remarkable figure, by the major British historian of the 20th century.

"Two impressive figures, William Morris as subject and E. P. Thompson as author, are conjoined in this immense biographical-historical-critical study, and both of them have gained in stature since the first edition of the book was published… The book that was ignored in 1955 has meanwhile become something of an underground classic—almost impossible to locate in second-hand bookstores, pored over in libraries, required reading for anyone interested in Morris and, increasingly, for anyone interested in one of the most important of contemporary British historians… Thompson has the distinguishing characteristic of a great historian: he has transformed the nature of the past, it will never look the same again; and whoever works in the area of his concerns in the future must come to terms with what Thompson has written. So too with his study of William Morris."
— Peter Stansky, *The New York Times Book Review*

"An absorbing biographical study… A glittering quarry of marvelous quotes from Morris and others, many taken from heretofore inaccessible or unpublished sources."
—Walter Arnold, *Saturday Review*

"Thompson's is the first biography to do justice to Morris's political thought and so assemble the man whole… It is not only the standard biography of Morris; it makes us realize, as no other writer has done, how completely admirable a man this Victorian was—how consistent and honest to himself and others, how incapable of cruelty or jargon and, above all, how free."
—Robert Hughes, *Time Magazine*

Anarchist Seeds beneath the Snow: Left-Libertarian Thought and British Writers from William Morris to Colin Ward

David Goodway

ISBN: 978-1-60486-221-8
$24.95 420 pages

From William Morris to Oscar Wilde to George Orwell, left-libertarian thought has long been an important but neglected part of British cultural and political history. In *Anarchist Seeds beneath the Snow*, David Goodway seeks to recover and revitalize that indigenous anarchist tradition. This book succeeds as simultaneously a cultural history of left-libertarian thought in Britain and a demonstration of the applicability of that history to current politics. Goodway argues that a recovered anarchist tradition could—and should—be a touchstone for contemporary political radicals. Moving seamlessly from Aldous Huxley and Colin Ward to the war in Iraq, this challenging volume will energize leftist movements throughout the world.

"*Anarchist Seeds beneath the Snow is an impressive achievement for its rigorous scholarship across a wide range of sources, for collating this diverse material in a cogent and systematic narrative-cum-argument, and for elucidating it with clarity and flair… It is a book that needed to be written and now deserves to be read.*"
— *Journal of William Morris Studies*

"*Goodway outlines with admirable clarity the many variations in anarchist thought. By extending outwards to left-libertarians he takes on even greater diversity.*"
— Sheila Rowbotham, *Red Pepper*

"*A splendid survey of 'left-libertarian thought' in this country, it has given me hours of delight and interest. Though it is very learned, it isn't dry. Goodway's friends in the awkward squad (especially William Blake) are both stimulating and comforting companions in today's political climate.*"
— A.N. Wilson, *Daily Telegraph*

"*The history of the British anarchist movement has been little studied or appreciated outside of the movement itself.* Anarchist Seeds beneath the Snow *should go a long way towards rectifying this blind spot in established labour and political history. His broad ranging erudition combined with a penetrating understanding of the subject matter has produced a fascinating, highly readable history.*"
— Joey Cain, edwardcarpenterforum.org

Damned Fools In Utopia: And Other Writings on Anarchism and War Resistance

Nicolas Walter
Edited by David Goodway

ISBN: 978-1-60486-222-5
$22.95 304 pages

Nicolas Walter was the son of the neurologist, W. Grey Walter, and both his grandfathers had known Peter Kropotkin and Edward Carpenter. However, it was the twin jolts of Suez and the Hungarian Revolution while still a student, followed by participation in the resulting New Left and nuclear disarmament movement, that led him to anarchism himself. His personal history is recounted in two autobiographical pieces in this collection as well as the editor's introduction.

During the 1960s he was a militant in the British nuclear disarmament movement—especially its direct-action wing, the Committee of 100—he was one of the Spies of Peace (who revealed the State's preparations for the governance of Britain after a nuclear war), he was close to the innovative Solidarity Group and was a participant in the homelessness agitation. Concurrently with his impressive activism he was analyzing acutely and lucidly the history, practice and theory of these intertwined movements; and it is such writings—including 'Non-violent Resistance' and 'The Spies for Peace and After'—that form the core of this book. But there are also memorable pieces on various libertarians, including the writers George Orwell, Herbert Read and Alan Sillitoe, the publisher C.W. Daniel and the maverick Guy A. Aldred. 'The Right to be Wrong' is a notable polemic against laws limiting the freedom of expression. Other than anarchism, the passion of Walter's intellectual life was the dual cause of atheism and rationalism; and the selection concludes appropriately with a fine essay on 'Anarchism and Religion' and his moving reflections, 'Facing Death'.

Nicolas Walter scorned the pomp and frequent ignorance of the powerful and detested the obfuscatory prose and intellectual limitations of academia. He himself wrote straightforwardly and always accessibly, almost exclusively for the anarchist and freethought movements. The items collected in this volume display him at his considerable best.

"[Nicolas Walter was] one of the most interesting left intellectuals of the second half of the twentieth century in Britain."
— Professor Richard Taylor, University of Cambridge

"David Goodway has done his usual excellent job of selecting an interesting and varied collection [and] contributed a most useful and informative introduction…"
— Richard Alexander, *Freedom on The Anarchist Past*